W9-CEW-276

THE RIGHT SIDE OF FORTY

CELEBRATING TIMELESS WOMEN

Photography by Leif Zurmuhlen ~ Edited by Patricia Martin

Foreword by Olivia Goldsmith

CONARI PRESS
Berkeley, CA

I dedicate this book with love to my husband, Richard, who constantly inspires me to stay on "the right side of forty."

–P. M.

This book is dedicated with love to my wife, Jill Anthony, for letting me look at older women.

–L. Z.

Photography copyright © 1997 by Leif Zurmuhlen and text copyright © 1997 by Patricia Martin
Foreword copyright © 1997 by Olivia Goldsmith

All Rights Reserved.
No part of this book may be used or reproduced in any manner whatsoever without written permission, except in the case of brief quotations in critical articles or reviews. For information, contact Conari Press, 2550 Ninth Street, Suite 101, Berkeley, CA 94710-2551.

Conari Press books are distributed by Publishers Group West

ISBN: 1-57324-095-8

Cover and interior design concepts by Richard Skiermont
Cover photos of author Patricia Martin at age 42 taken by Leif Zurmuhlen
Cover design by Suzanne Albertson
Interior by Jennifer Brontsema

Library of Congress Cataloging-in-Publication Data
Zurmuhlen, Leif, 1962–
The right side of forty : celebrating timeless women / photography by Leif Zurmuhlen ; edited by Patricia Martin.
p. cm.
ISBN 1-57324-095-8 (hardcover)
1. Photography of women. 2. Middle aged women–Portraits. 3. Middle aged women–Interviews.
I. Martin, Patricia, 1953– II. Title.
TR681.W6Z87 1997
779'.24–dc21 97-24308

Printed in the United States of America on recycled paper.
1 3 5 7 9 10 8 6 4 2

FOREWORD

A society condemned and burned Joan of Arc because she not only heard voices but she acted on them. This, for women, stood as a warning as well as a sanctified act.

I worked for years in the corporate world. Like Joan, I donned men's clothing—the corporate suit—and went out to do battle. But my own inner voices told me that this was a meaningless war for me. It wasn't what I should be doing. Yet the so-called realities of life—mortgage payments, telephone bills—kept me deaf to the internal whispers. The fact that books were all I cared about struck me not as a calling but as a useless peculiarity.

Then one day in my reading I came across a line written by Ninon de Lenclos: "Old age is woman's hell." The line hit me hard. It didn't say that old age was people's hell, or even women's hell, but that singular woman, that lonely woman entombed—as I imagined her—in an isolated, frightening old age stared out at me from the words on the page. The image did not go away. Why, I wondered, was old age worse for a woman? Partly because society—even now—frequently insists that women are valuable only for their youth, ability to breed, and decorative charm. But also, I think, because so many women had spent their lives doing what they were told to do: taking care of others, meeting other people's needs. It leaves one waking up at the end of a long life drained and often bitter.

It's never too late—in fiction or in life—to revise. At thirty-five, I decided to listen to my voices—to try and live a more meaningful life. And, though I was warned it was a foolish mistake, I changed. I began to write novels. I'm glad I did.

Now I, along with the others of my generation, have moved into middle age, and what I'm finding is that the pleasures here are rich. At forty I knew who I was—the good bits and the bad bits—and no one could shake my faith in myself on the good bits.

Like Irene Mayer Selznick, "I'd like to grow very old as slowly as possible." The women in this book are at various points on their personal road, but all of them are on the more authentic side of forty. Each one, frozen as she is in a moment in time, seems beautiful and interesting. I hope these images and voices, captured by Leif Zurmuhlen and Patricia Martin, inspire and support. That these images are strong, beautiful, vibrant, and individual is not surprising. Let them add to our culture's vision and understanding of women.

Age may inevitably take some physical grace and add some physical limitations, but it also grants us self-knowledge. It allows us to take the parts of life that are not serious more lightly and to focus on those things important to each of us with greater clarity and vision.

The temptation and traps to draw a female away from her authentic self are mind boggling: makeup, fashion, "good girl" behavior. These are all yawning chasms, trapping some of us for years with false blandishments. Although there is a long history—and a proud one—of rebel men images, there is no path for a young rebel woman. It takes years for most women to drop the nonauthentic self, to let the real one emerge. Most of us don't do it till we reach the other side of forty. In this book we hear many voices—a trucker, a martial artist, a flirt, a dancer. These photographs, these voices, all so varied, share a single trait: a level of self-knowledge and comfort with that knowledge. It took me years to hear my own voices, more years to learn to listen, and still more to act. I'm still learning. This book helps.

—Olivia Goldsmith

EXPERIENCING THE RIGHT SIDE OF FORTY

I am turning forty-four this year. It sounds like a very big number, and I am somewhat ambivalent about identifying with it—on the one hand, getting older has been a wonderfully liberating unfolding of self-discovery; on the other hand, I don't relate at all to the standard images of middle age that have been foisted on us by the media. I like being where I am—I just don't want to be where they say I should be. My thirteen-year-old goddaughter recently gave me one of the nicest compliments I've ever had in my life. She said, "Aunt Patti, you're a grown-up, but you haven't forgotten what it's like to be a kid." I hope I never do.

Over the past ten years, I've noticed subtle signposts of aging and have found them to be both amusing and annoying. The first time a store clerk called me "ma'am" I turned around to see who was standing behind me—he couldn't *possibly* have been talking to *me*! Even though I've grown accustomed to the term, I still don't *feel* like a "ma'am." In my mind's eye, "ma'ams" are matronly, kindly, unhip, "Aunt Bea" types.

I am especially fond of my Aunt Mary and my Aunt Annie, both of whom are now in their eighties. Ten years ago I was marveling about how much they've seen during their lifetimes, and I asked them what it felt like to grow old. Aunt Mary answered, "You have more experiences, you grow a little wiser, but somewhere inside you still feel like you're sixteen years old. Then you go to get out of bed and are shocked when your body reminds you how old you *really* are!" Aunt Annie laughed and nodded in agreement.

I get incensed about stereotypical age prejudices. I once went on a diatribe after reading a schlocky syndicated celebrity question-and-answer column. A reader asked why Glenn Close would agree to play a "silly character" in the movie *101 Dalmatians*—she thought the role was far beneath Close's talent. The columnist—a man, of course—replied that "At forty-nine, she can no longer hope to be cast as the romantic lead in Hollywood movies." Even today, more than a year after this column appeared, I still see red just *thinking* about it.

According to conventional wisdom, forty is the transitional year when a woman crosses a threshold and is banished to middle-aged limbo. Bring on the black balloons—you're over the hill and past your prime, on the road to steady decline. The world tells us this, and some of us have bought into it.

In the 1989 comedy, *When Harry Met Sally,* the character Sally is devastated when she hears that her ex-boyfriend has gotten engaged. She is crying on Harry's shoulder, convinced that something must be terribly wrong with her. The thirty-two-year old wails, "I'm going to be forty . . . Someday . . . It's just sitting there like this big, dead end. And it's not the same for men." This statement is sad but true—but I am confident that contemporary women are making great strides in dissolving stereotypes, exploding myths, and establishing a vibrant new image of what it means to be forty-plus.

That's where this book comes in. The idea came about in August of 1995. A good friend of mine threw a party to celebrate her new home and my forty-second birthday. Leif and his wife, Jill, attended the party, and Leif was struck by the number of captivating and beautiful women—all over the age of forty—who were gathered under one roof. He found them compelling in a way that was far different from the younger models he typically photographed and thought they'd make an intriguing study. Being a writer who is fascinated by people and what makes them tick, I was excited by the prospect of interviewing my peers and delving into their hearts and minds.

Leif and I made a commitment to pursue our vision of celebrating mature women through honest, unaltered black-and-white images with an accompanying text of revelations in their own words. We began soliciting candidates, distributing questionnaires, and setting up appointments for photo shoots and interviews. As it is with most labors of love, the project took on a spontaneous life of its own. It gives us great pleasure to have it come to fruition and manifest in this volume of work.

What does it mean to be on the right side of forty? To Leif and me, it implies women who have reached the age of forty—and beyond—but who are timeless in the sense that they transcend conventional stereotypes of what it means to be a middle-aged woman. Each one of these

individuals is unique and extraordinary, exuding a confidence that is enhanced by age, experience, and feeling comfortable in her own skin.

Women on the right side of forty don't deny their age, and they don't lament the passing of youth. Instead, they choose to redefine midlife as a positive place to be, physically, emotionally, and spiritually. Embracing life with a genuine joie de vivre, these women are gutsy and upbeat; strong and sensitive; wise and witty; sensual and beautiful. They are a remarkable force to be reckoned with—and to admire.

This is not to say that these women have been untouched by life. While some have led lives of great privilege, others have experienced extreme poverty, prejudice, or abuse. In interviewing these women, I heard stories of coping with illnesses or addictions; loves lost and loves found; the grief of losing a child, husband, or other loved one; happy endings and fresh, new beginnings. I was told some incidents off-the-record—including reports of rape and incest—but the request for confidentiality was always made to protect the feelings of others. Conversely, I was told tales of unsung sacrifices and good deeds that the women did not wish to tout. The interview process was like a microcosm of the depth and breadth of human existence, played out in the myriad stories of these women's richly diverse lives.

Being a part of this book was not a passive process. Prior to a one-on-one interview, each woman filled out a three-page questionnaire that asked a broad spectrum of deceptively simple questions. Most of the questions were wide open to interpretation, such as: Where were you in your twenties/thirties/forties/fifties? Where are you now? Where are you going? What has given you the greatest joy and satisfaction in your life? What would you do differently if you had a chance? What advice would you give younger women?

The majority of the women told me that completing the questionnaire was a catalyst for deep soul searching—which they either loved or hated. A few said it triggered a personal crisis of sorts that lead to major—but ultimately positive—life-altering decisions.

The women featured in *The Right Side of Forty* are an incredibly diversified group, with varied talents, lifestyles, and life experiences. After speaking with them, I had a strong sense of how bland, boring, and incomplete life would be if we were all the same. While the common ground of feminine sensibilities unites us, our diversity is our strength. I was truly gratified and honored by how amazingly open and honest the women were with me—and with themselves.

A few of the women I interviewed for the book are involved with men who are a decade or more their junior. They are very much aware that when a man has a relationship with a younger women, it is acknowledged by the Greek chorus of society with a nudge and a wink. But when a middle-aged woman is with a younger guy, the liaison is immediately suspect. People speculate that either she has a lot of money, or he has an Oedipus complex—what else could he possibly see in her?

I myself am married to a man who is nine years younger than me. He is my second husband and my one true love. Our age difference just isn't an issue for us—we don't even think about it except when one of us is having a birthday, and we joke that once every ten years we get to be in the same decade.

I was crushed when my mother died after a brief but valiant battle with cancer—I was a rebellious twenty-year-old and she was just fifty-three. For a petite, infuriatingly strict Irish Catholic mom, I thought she was kind of cute and awfully smart, with a keen sense of humor. My older brother's friends would often come to visit her after he was drafted into the Army, and I would tease her and call her "Mrs. Robinson." Although she protested, I could tell she was not altogether displeased by the notion that younger guys might find her attractive and interesting in her own right.

During our tumultuous relationship, my mother and I had been through many passionate battles of the will, soulful late-night talks, and hysterically funny escapades. Even though I had a strong independent streak and yearned to be out from under her thumb, we had a fiercely loving bond that was tight and true. We kept each other on our toes, and I have come to realize that I am more like her than either one of us would probably ever have wanted to admit. I wish I could know her now, as a mature adult. I'd like to think we'd acknowledge and appreciate each other as women on "The Right Side of Forty."

–Patricia Martin

FOCUSING ON OLDER WOMEN

Since I first began photographing people when I was thirteen years old, women have always been my favorite subject. It seemed very natural. I really enjoy the company of women and I appreciate all kinds of beauty. As a commercial photographer, however, I've become bored with the limited idea of what we are supposed to find attractive that we are fed by movies, TV, and magazines. So when Patti and I decided to collaborate on this book, I was excited to focus on what I found visually appealing and interesting in mature women.

As a photographer in my early thirties, I approached these older women without the customary respect I would usually afford my elders. I thought that would make for dull photographs. I tried to capture what I found compelling and attractive about each woman. They were very accommodating as I snooped around in their homes looking for the perfect location, rooted through their closets looking for the right outfit, or rearranged their furniture until my picky eye was satisfied. Each portrait is a collaboration with the subject. Their ideas were as important as mine in arriving at the final composition. I was constantly surprised with their inventiveness, energy, and willingness to hold some very uncomfortable but great-looking poses.

I've had the pleasure of spending time with every woman you see in this book. It's been great fun and their reactions to the work in progress were very encouraging. They seem proud to be shown as they are, in all their glory, and I think they look great!

As I worked on the book and showed the photos around, the comments I heard most often were how refreshing it was to see mature women photographed in all their natural beauty, without retouching or soft-focus lenses, and how unique it was to see a collection of photographs on older women, period!

The depth, strength, character, and wisdom of these women's full lives is evident in their eyes, faces, and bodies, and I hope that I've succeeded in capturing a bit of that to share with you. And I hope, for my own sake, that men can age with such grace, humor, and potential.

–*Leif Zurmuhlen*

THE WOMEN

BORN: 5/3/55

If something is beautiful and flattering on you, I say wear it.

If something makes you giggle, I say do it.

I dare to wear anything!

I am a Taurean woman who loves the finest things: exotic foods, good wine, and days full of sunlight;

silks, chiffon, and black lace; skillful dancing partners and—oh yes, I almost forgot—hats!

I grew up very poor in Puerto Rico and yet felt privileged to have a family with the strongest moral and social values. I was taught the

true sentiment of social responsibility: to work hard and be generous, kind, and dedicated. That shaped my indomitable spirit!

I am first a person, then a woman. Women today are not satisfied with following old rules or conforming to expectations.

We're more deliberate about carving our futures and finding fulfillment. We've also learned the joy of expressing ourselves through

the images we present to the outside world. I personally like to dress up, sometimes provocatively but always elegantly.

I am not afraid of looking feminine to provoke the onlooker.

A woman does not have to be beautiful to be sexy, nor does she have to be clothed in silks and lace.

The confidence with which she carries herself is what makes her glow with sex appeal.

Insecurity is our enemy. Women should try hard never to feel threatened by another self-assured woman—

a sense of competition undermines us all. When we meet an excellent woman who is smart, intelligent, and capable,

we should try to emulate those attributes that we admire. It's important for us to encourage each other's strengths

and be supportive of each other's differences.

Life is temporary, a loan. One must live it to the fullest. Be true to yourself, be kind to others, and always stand up for your principles.

Why hide your light under a bushel?

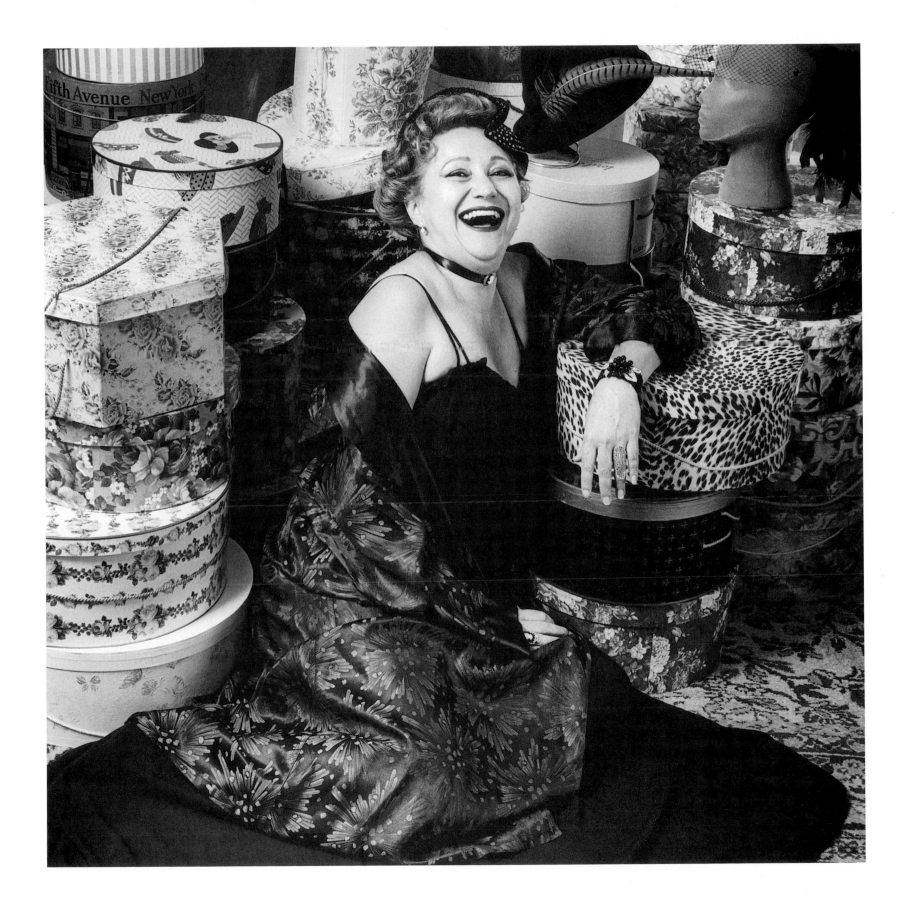

ELIZABETH HENDERSON

BORN: 1/13/43

This is my second life—in a sense I have already "died" once, so I need not be afraid of risk.

In my thirties I was a newly widowed single parent teaching Russian literature, language, and film history.

Academia was the world I entered with my husband, but I did not care to stay there alone.

After my husband died, I lived with some friends who would start a garden every year but then not follow through.

I did the weeding, and when the crops ripened, I harvested them. I found something soothing about growing food and flowers.

It was a way for me to heal my relationship with the universe, which had put me in such a painful place.

I now find myself in the position of diplomat, bridging the organic food movement and conventional agriculture.

I farm full-time, producing vegetables and fruit, most of which are sold through a food cooperative that serves a group of consumers

within a sixty-mile radius. I get to know well the people who eat our food. It's more like growing for friends than doing business.

Being a woman has never been a problem for me. My parents raised me as a human being.

They gave me the confidence to face what life has sent my way and to honor the full range of human sexuality and sensibility.

I came into consciousness in the era when Marilyn Monroe was the feminine ideal.

There was no way in the world I could look like that! Through modern dance I came to feel good about my body and myself.

I like ballet, but the experience of modern dance is how I got in touch with the natural.

I try to live in such a way that I increase the possibility of peace in this world, peace among human beings and between us

and our natural surroundings. One of the benefits of farming is what a farmer friend refers to as "aesthetic gluttony":

the pleasure of being out in nature with birds, plants, insects, the soil, and the sky.

The path I have chosen in life is a physically arduous one.

I could have made life much easier for myself, but not more engaging, challenging, and interesting.

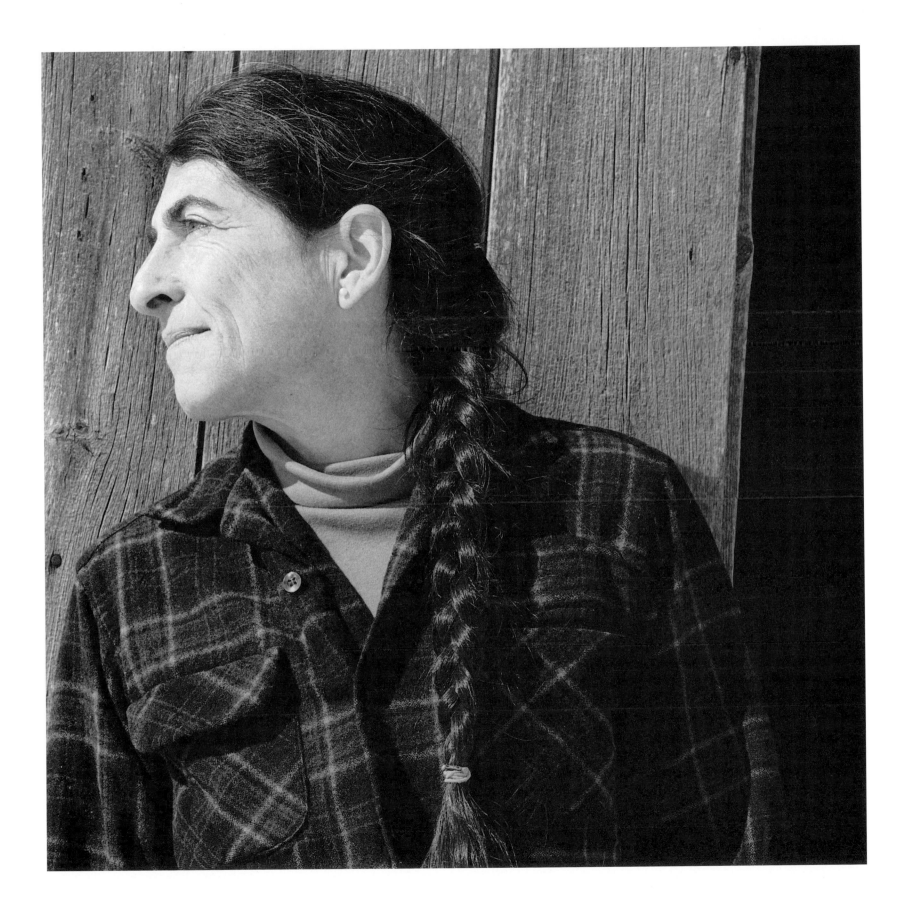

SUSIE CARMAN

BORN: 8/16/55

I am truly a "Water Woman."

The magic starts when you catch a wave. Lying flat on the water and looking up at this aquatic mountain thundering down on you is intimidating. The trick is to not fight it, but to be one with the water. When you fight it, you fail—it's like that with all things in life. You just have to go with it, and be so "there" that there's nothing on your mind. At that moment you're empty of chaos and trashy thoughts. It's spiritual: a meditation. When I'm in the water surfing with friends, I feel like we're in church.

I still consider myself a novice at surfing. I like being in constant awe and challenging myself. When I do it right, it's so graceful. Listening to the music of the wind, the waves, and my own inner music, I feel like I'm doing the most incredible dance of my life. It's joyful, beautiful, and soulful.

I flow where things take me and have never held myself back. Hawaii is my home, but I usually spend four or five months a year in Europe. I go in and out of periods where I'll stay home and nest for a while, then want to travel again.

I began traveling when I was nineteen, when I drove from New York to Florida with $100 in my pocket. I became friends with some people who had a sailboat and we took off for four years, sailing the Caribbean, Central America, Mexico, and the South Pacific. It wasn't something I planned, just a natural progression.

As you age, it's odd how the mind takes over where the body left off. I feel blessed to be a woman. We need to take control of our own minds and actions, not let the media lead us around as if we're brainless.

As long as I'm still moving, I've got to get out there and do what I truly love. I'm going to surf forever. I want to be the world's oldest living surfer.

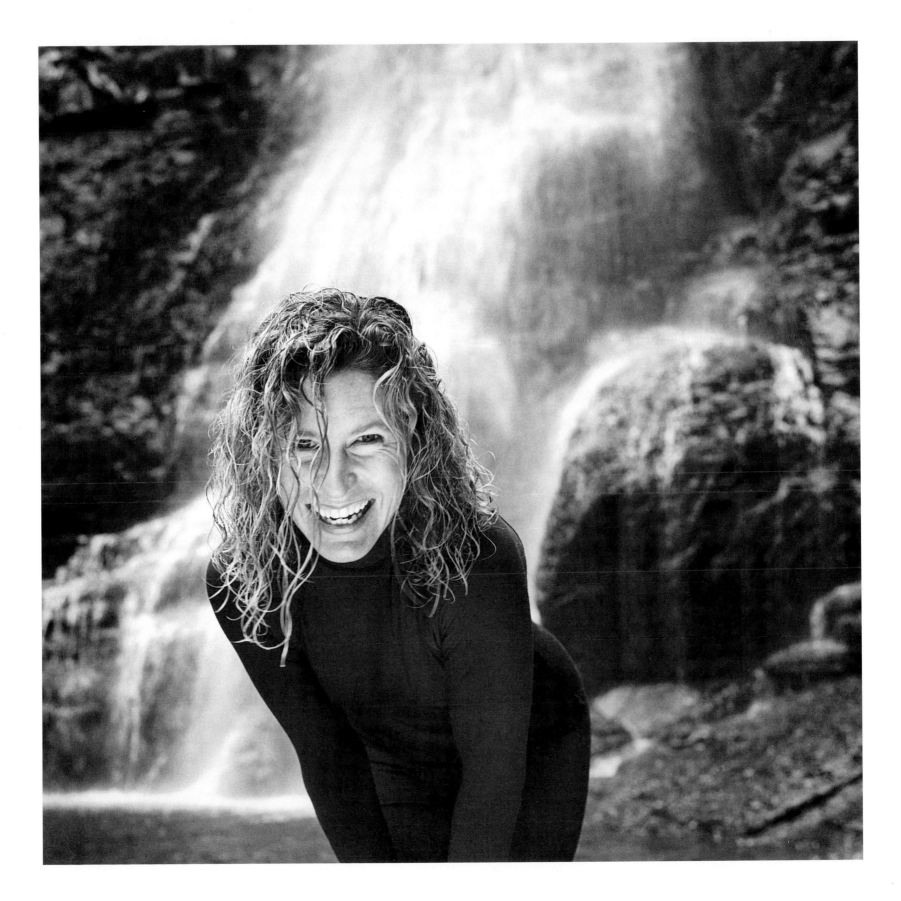

TERRI JOHNSON

BORN: 6/8/51

For years I had fantasies of climbing Mount Everest—literally. In a sense I've climbed my own personal Mount Everest and have just reached a summit. I battled with depression and worked very hard to get to this point in my life. While I'm enjoying the view and feeling very contented, I'm sure I'll find other challenges and will start climbing again soon—something *always* comes along that I have to deal with, but that's OK. Challenges keep me moving forward and help me grow.

I used to be afraid of myself and my individuality, feeling like I had to look, dress, and act a certain way. Society does not support uniqueness—there's a lot of pressure to stay in a box and follow the rules. But as an artist, I can't succeed if I stay in a box. I now realize that my own style is right for me and that the things I love most are the things the come from my heart.

I love bright colors and never use black in my paintings. I'm pleased that my artwork is finally where I want it to be, expressing what I have to say. I like to feel that what I do, I do joyfully and well. I want to give something to the world that touches people's hearts and lifts their spirits.

Age is a myth that a lot of people believe. A certain number hits on the calendar and they think they have to slow down. But when the body and mind keep moving they stay young. Personally, I need a thirty-six hour day to do everything I want to do! Unless I study myself in the mirror closely I don't think of myself as old—I feel alive and vibrant and part of life.

Artists don't retire. I want to continue to explore and express myself as long as I can. I hope to die with a paintbrush in my hand.

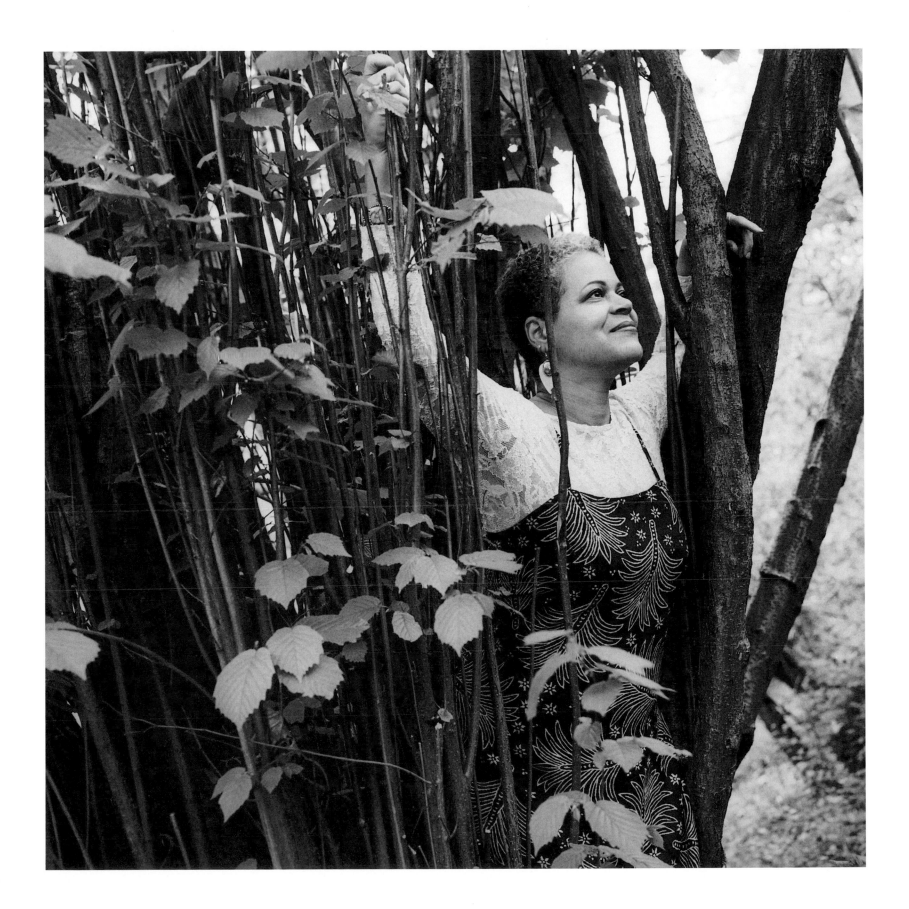

It's scary and exhilarating at the same time to be in my early fifties. I'm now going through what most women experience

during their teens and twenties—I'm learning to have faith in myself and define myself in my own eyes, not as others see me.

It's a journey of exploration, and there are some pretty scary animals out there—including me!

In my thirties I began to understand and use my power as an attractive woman. While my looks were not traditional, I did seem

to have something that people responded to—I had bones and I sparkled. I now vacillate back and forth between thinking that I look and

feel pretty good, to seeing an older, unfamiliar face. I have so much more to me now, but my body doesn't always match the vitality I feel.

We live in an age when we can change what time has done to our faces and bodies. Sometimes I stand in front of

the mirror, pull at my chin, lift my eyes, stretch my neck . . . but hey—I'm fifty-one, I don't need to look like a thirty-year-old.

What's wrong with a society that says a woman over a certain age should even think about plastic surgery?

Without my women friends, I don't think there would have been a women's movement. A lot of us,

myself included, were among the growing legion of working mothers. We held each other up and pulled one another along

through the raging waters and crashing thunder of a disapproving society.

I love being a woman, and now is the time to be one. We are just now coming into our power, as I'm sure any woman who's

gone through menopause can feel. I'm proud that my generation is a force to be reckoned with, and we're hell-bent on changing

the way the world views mature women. At this point, I don't even think the word matronly belongs in our vocabulary!

There is a sense of serenity, even in my groping for an ephemeral new life. I feel a connectedness to other women and a new-found

strength. I am becoming more powerful, and more beautiful, through my conviction and self-acceptance.

I want to be cremated and have my ashes sprinkled over the earth. My urn should say: "She drank the wind and flew."

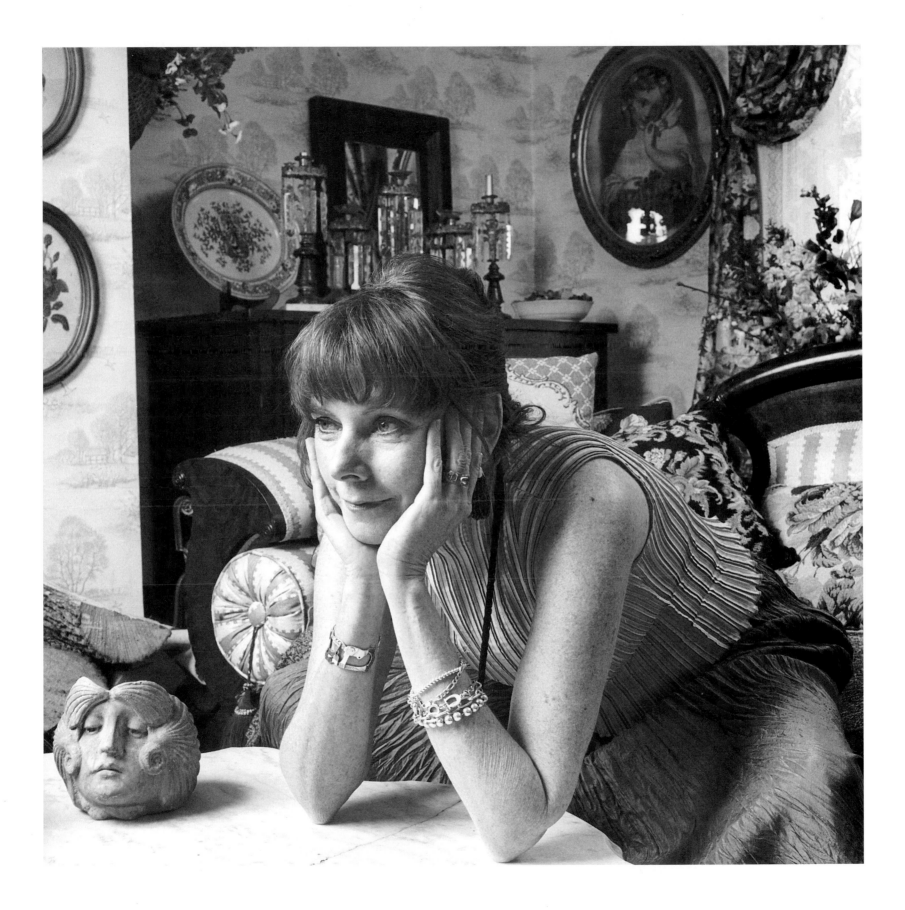

SHARON WEISBERG

BORN: 10/23/45

On my fiftieth birthday, I began to celebrate my life.

I traveled to a remote part of a beautiful Caribbean island, alone, in order to indulge myself in the simplicity and beauty of nature.

I stayed at an intimate little place that was built like a temple, open to the ocean and sky. I meditated, snorkeled, did yoga, and rested.

I wanted to go into my fifties in a special way, and this was ideal.

One thing I began to appreciate when I was there was how the simple things in life are really not simple at all.

A sunset is a tremendously moving experience we can have every day. And look at the stars—there's a whole show going on up in the sky

every night. When I returned home, I discovered a breast lump that turned out to be malignant. I was alone when I got the diagnosis,

and my strength was challenged. After doing a lot of research and soul-searching, I decided to undergo surgery to remove the lump

and surrounding tissue, followed by chemotherapy and radiation. I kept saying to myself,

"What can I do to get through this and make the best of it?"

I did not change my lifestyle during the therapy treatments. I continued to work full-time at my job

and do all the activities I enjoy, like working out. I pursued fun and joy—great antidotes for sadness and depression—

by learning new things, like zydeco dancing.

I refused, and still refuse, to be a victim of cancer.

It's comforting to me that we don't remember what happened before we were born. Maybe death is another rebirth,

a new way of being. The idea that death may be a birthing process we don't comprehend is very reassuring.

From the moment I was told that I had a malignancy, it was as if I began holding my breath. It's been almost a year now,

and I feel like I'm starting to breathe again. The way I look at it, I've gotten through chemo and radiation and now it's behind me.

I closed the door. I'll deal with it if it comes back, but I won't immerse myself in it.

I will go forward as if I'll live forever.

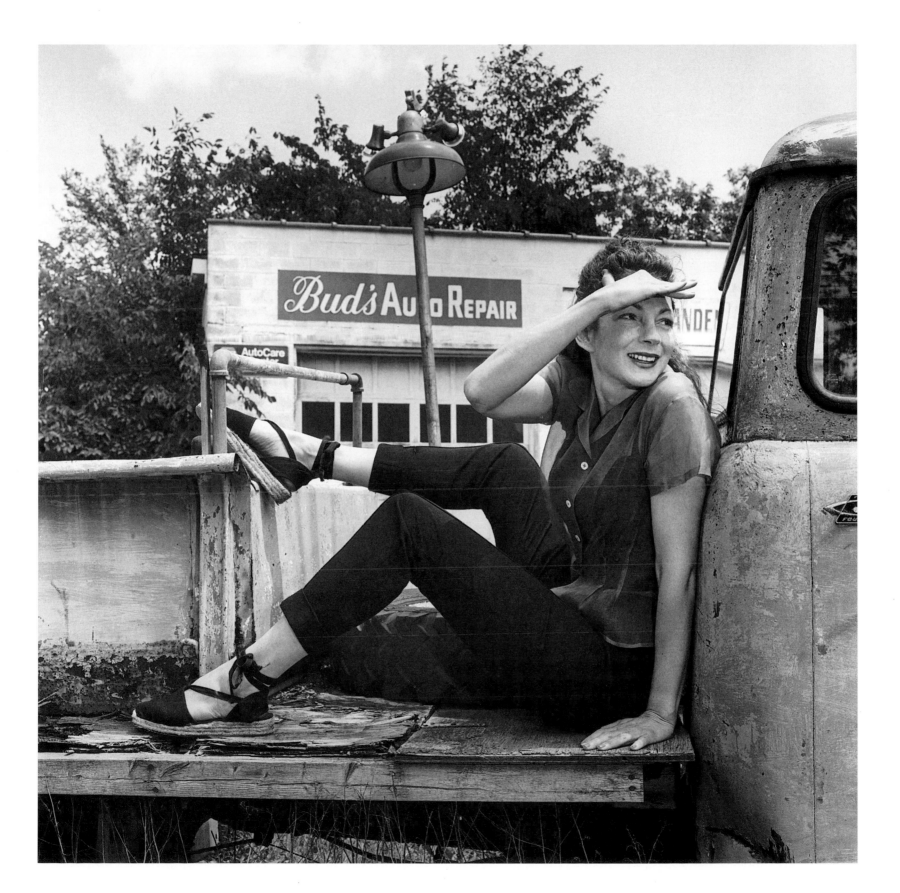

I can't imagine my life without the incredible experience of pregnancy and giving birth.

I felt centered and was in touch with every part of my body, mind, and soul—even though I puked five times a day!

I feel like I've finally arrived and know where I'm going. I'm at the perfect age:

old enough to have the wisdom to apply my gifts, and young enough to still have the energy to be active.

To have passion in your life—no matter what it is—is important.

I love pouring my energy into what I do, and striving for excellence. I'm lucky to have a career that is meaningful,

creative, and fulfilling—promoting literacy at an international school through music, dance, and drama.

As I mature I want to keep pushing myself out of the comfort zone by doing things I've never done before.

Youth is so willing to grasp at new experiences. Because my daughters and students have such an insatiable hunger to learn

and take risks, they inspire me to stay young at heart.

Getting older is so freeing and wonderful—you don't waste time being embarrassed, ashamed, or afraid.

I try to explain this to my daughters when I see how many of their waking hours are spent worrying, but I don't think

they believe me! When they are grown women, I hope my words come back to them like a soft whisper. Sometimes

I try to shield my daughters, but I remind myself that part of being a mother is working yourself out of a job.

If you've done it well, your children will be strong enough to stand on their own.

We've faced some prejudice as a biracial family, and "whiplash" when people see us for the first time and try to figure us out.

Our daughters don't think in racial terms, but have formed their identity based on who they are inside. We don't have to

preach the message that people of different races can live together—we are a living example of it.

All of God's children are beautiful and wonderful in their own special way. My daughters are an unbelievable gift,

testaments to the love my husband and I have for each other.

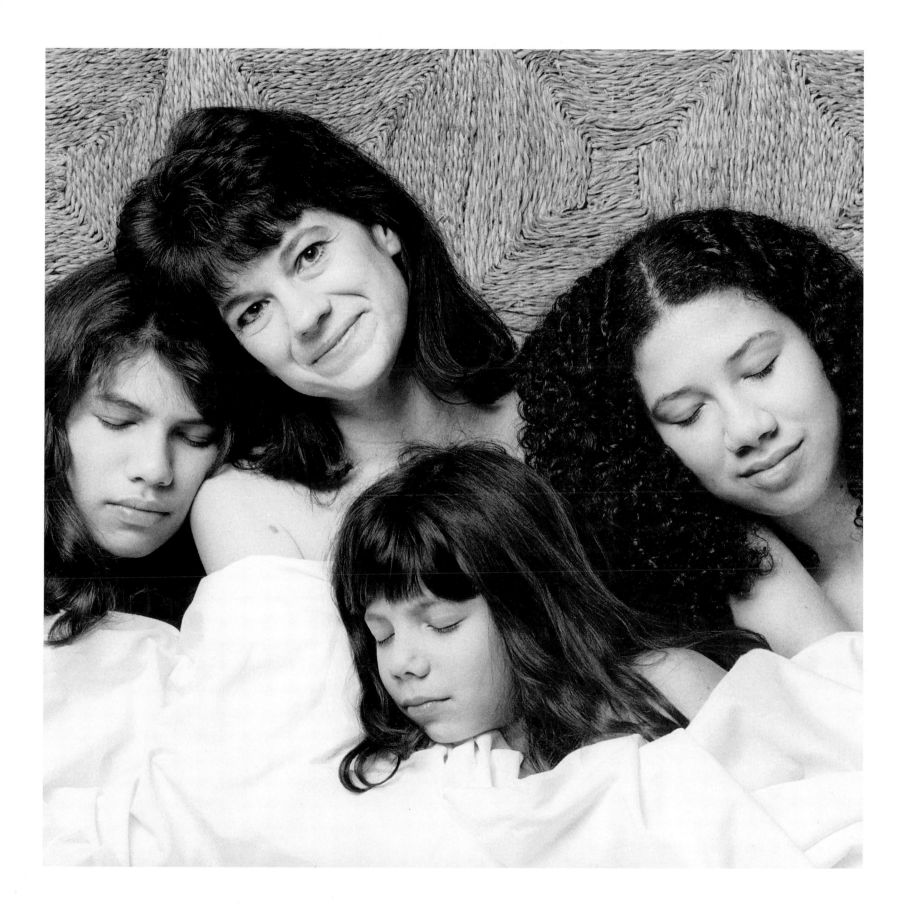

At forty you're like the rose in full bloom—it's a time of coming into your own and truly knowing who you are.
Your greater self is trying to get out there and be.

You can get immobilized by the political correctness of what you're *supposed* to be. But by the time you're forty
you realize this is hogwash! The beauty of the other side of forty is that it doesn't stop you anymore.
It's not like it doesn't go on—you're just more willing to risk to become fully who you are.

In our bodies, women experience monthly the process of the creativity of life. Unfortunately, society raises us to feel like
our cycles are shameful. It's important for us to acknowledge our cyclic wisdom, experience it, and embrace it.

There are cycles within cycles, but the most obvious one is menstruation. It's biological and spiritual.
Like the dark of the moon and the full moon being 180° apart, women move from introspection and reflection to inspiration
and outward energy. Each month we prepare to give birth—and it's actually a birthing of ourselves.

During our forties, as women approach menopause, our testosterone levels rise—our "balls" kick in! We begin to experience this out-in-the-
world energy stirring within us. If we have lived according to our inner truth, our forties and fifties will be the time that we're maximally
in touch with our creativity. It's exciting for me to think that with each passing year I will become more and more courageous.

Women have been socialized to create harmony at their own expense, "peace at any price." That's the emotion behind many illnesses.
But our real responsibility is to be true to ourselves—it's the only way society will benefit from our gifts and talents.
It's our job to create what brings us the most joy in our lives.

I'm not satisfied with the split between private life and professional life—I have a whole life. As a physician and author,
I study scientific journals and medical literature and then try to apply the material in real, practical ways. If it holds water in my life,
I know it will relate to other women, as well.

I give women a bridge they can cross to trust themselves.
The more honest I am and the more intimate I am, the more universal my message becomes.

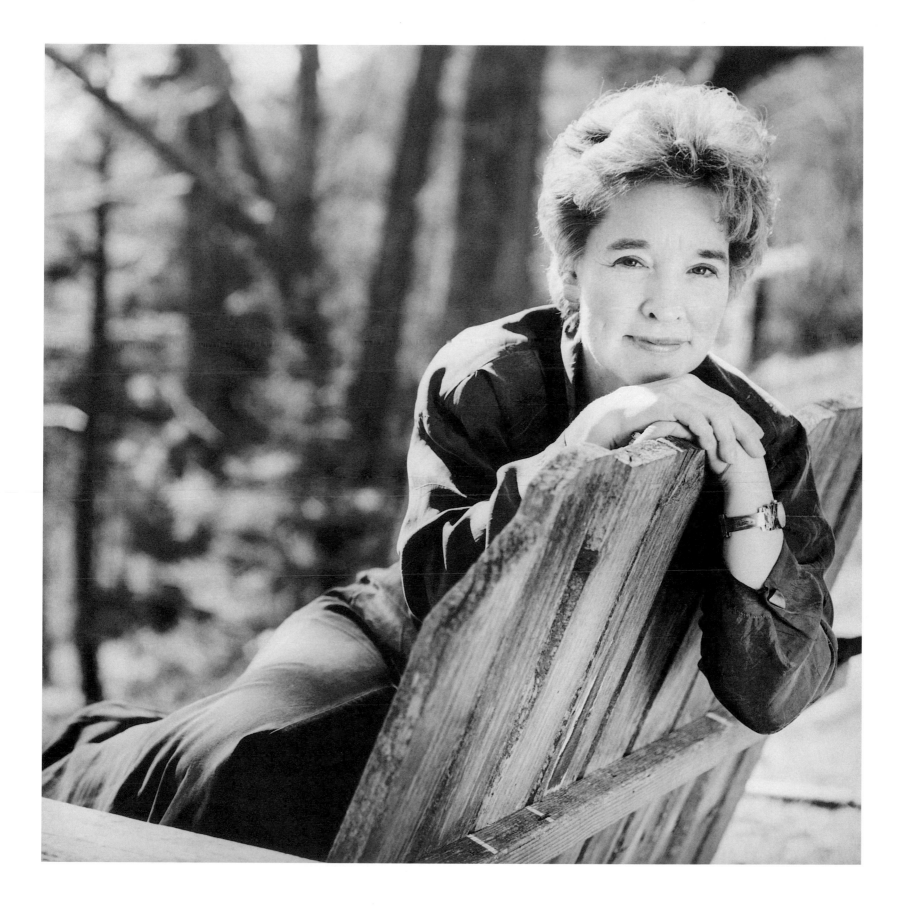

As a stylist, I live and work in the world of fashion. But I believe that no one, regardless of her age, should blindly follow what fashion

dictates. By the same token we shouldn't be shut down to what's new. When it comes to personal style, there are no hard-and-fast rules.

I don't want to be one way—I like being a chameleon. Whether it's my hairstyle or clothes, if I enjoy something and I want to wear it, I do.

I like being different every day—sameness feels confining.

I've never been a moderate person and can easily go from one extreme to the other. I'm able to relate to all types of people,

from straight conservatives to personalities who are completely over the top. I know both sides.

Being a unique individual can be difficult—it's sometimes easier to be mainstream. But I've learned I am who I am.

I try to be true to myself without compromising. I don't change my lifestyle just because somebody criticizes me—someone is always

going to have something to say. I'm not going to change my existence in order to make someone else feel comfortable.

I don't think about age that much. It's a process—you just keep going. Gray hair, it's happening. But I don't feel forty-three inside.

I approach every day as if I was young and, for the most part, totally disregard my age.

I'm not as concerned with myself as I was when I was young—I'm clear about who I am and what I want. I'm trying to simplify my life by

weeding out nonsense and developing a more Zen way of looking at the world. I'm stepping back and not feeling as caught up in things.

Instead of plotting out my future, I've always been impulsive, into moment-to-moment living.

My values, having freedom of choice, and personal happiness, are the only things that are really important to me.

I'm always open to experiencing something different.

I have a good sense of direction and am learning to trust the instinctive part of myself more.

Where I am now is in a good place. I just strive to make it better, daily, whatever it takes to feel fulfilled.

I'm not afraid of taking risks, being spontaneous, and following my intuition, wherever it leads me.

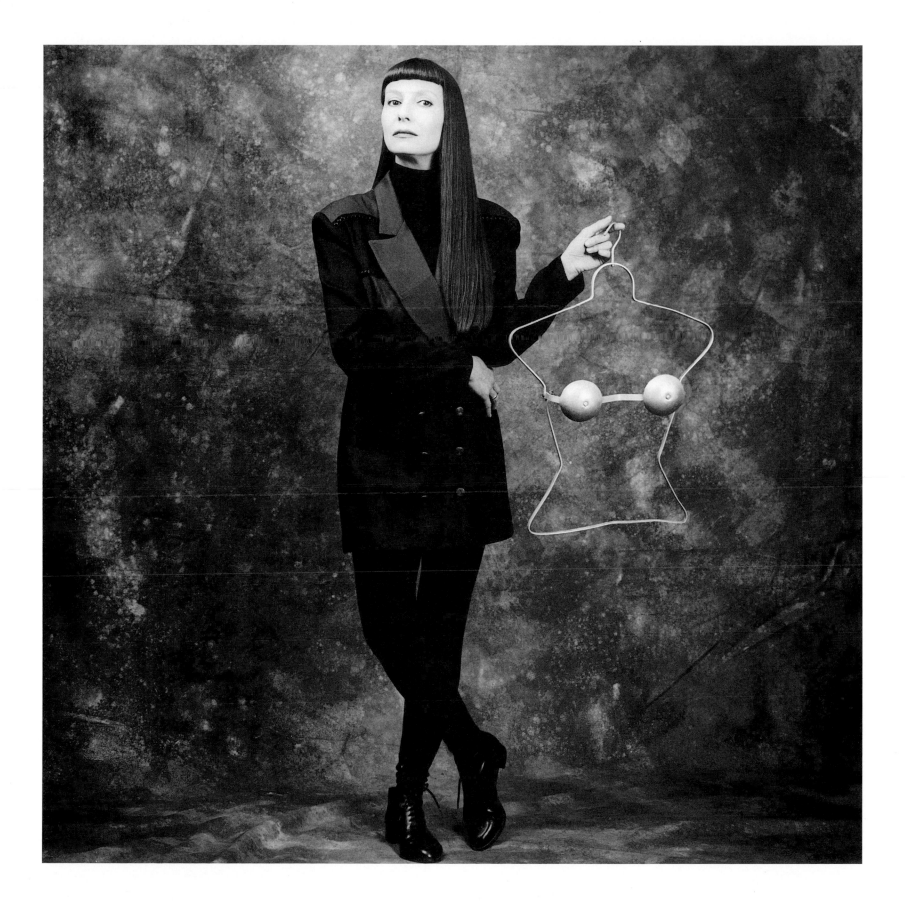

A N N E L U S K

BORN: 3/28/48

Modesty is a luxury afforded only by those who've already arrived. To be a role model for the next generation,

we women must lose our modesty and crow about our work by actively soliciting the spotlight. If no one knows what you do,

it may be worthwhile but it will have no significant impact.

As women we've been taught to be humble caregivers. Traditionally, older women have not achieved prominence

in their career lives—there are very few founding mothers whose footsteps we can readily follow in.

If a woman is mentioned in a national obituary, she is usually a celebrity.

After my marriage broke up, I dove into the comfort of research and studied what being single really meant.

I quickly realized that my options—blind dates, personal ads, dating services, bars—were like playing Russian roulette.

They're an abysmal waste of time that set people up for disappointment and rejection.

I wanted to see if I could come up with a better alternative and ended up founding the Singles Volunteer Network,

a concept that has spread nationwide. It grew from the idea that singles could connect by doing meaningful work: helping out at a

soup kitchen, building Habitat for Humanity homes, clearing park trails, and other worthwhile endeavors. It's a great way

to meet some really nice people while changing the face of the country.

I'm constantly surprised by my own strength. I've done well because I've pounded the pavement,

gone after recognition, and pursued the media. It doesn't come easy for me because I am basically a shy, self-conscious person

who doesn't like conflict. I'm able to do it because my work is bigger than I am—it's not about me, personally. I have the chutzpah to tackle

what most people think can't be accomplished because I believe in what I'm doing.

In your forties, life seems shorter than it was in your twenties. I figure I only have so much time left—let's burn the candle at five ends!

My glass isn't half-full but overflowing and, with the water that splashes out, I make gentle waves.

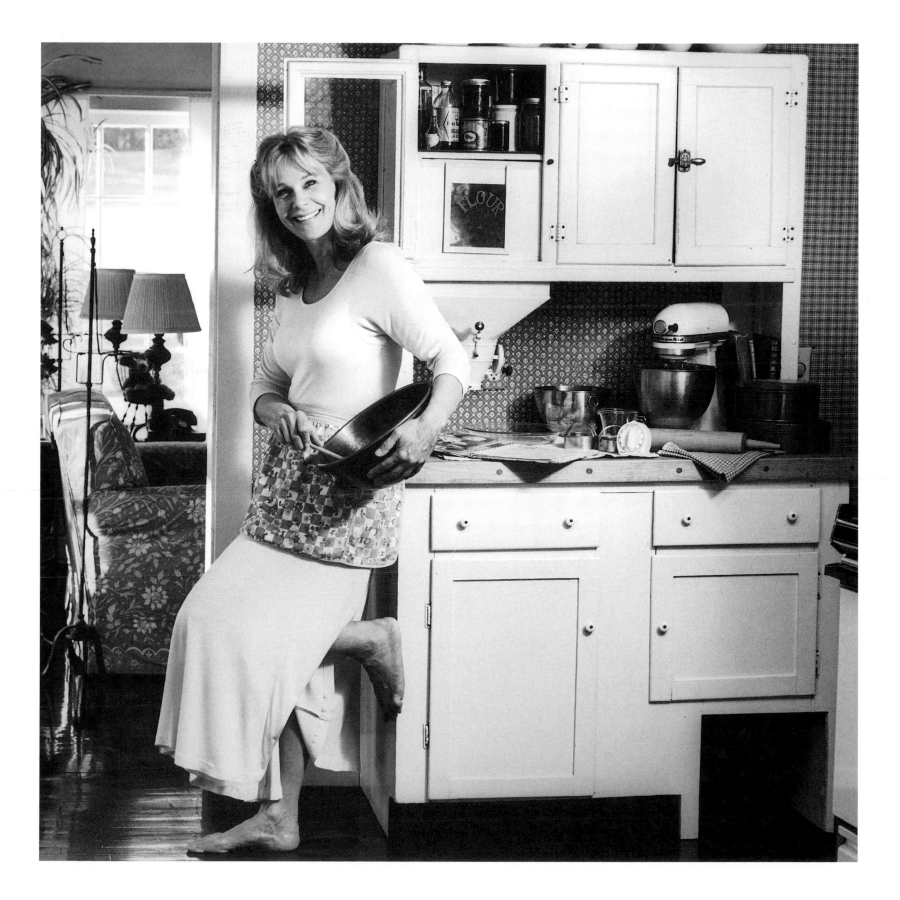

CYNTHIA COULTER

BORN: 1/16/51

I wasn't raised to be an artist—I was brought up thinking I should get married and stand barefoot by a trailer.

The only reason I went to art school was because I couldn't pass multiple-choice tests!

In art I could let it all hang out. I couldn't draw horses well but I didn't think that really mattered.

I was never a conventional artist and didn't follow the norm.

I wasn't afraid to express myself. I felt OK doing things that were different from what other people were doing.

I didn't care whether or not my art fit in—I only cared about being honest. I grew up arranging things—I changed my bedroom every day.

We didn't have a lot of money so my mother taught me how to make-do.

Mixed media is a reflection of this—it's *making do* by making things work that aren't necessarily supposed to.

Ever since I was a little girl, I have loved going through other people's junk.

Tag sales and dumpsters are great—found objects are my palette. The best description of my work is that it has this eked-out appearance.

I like the fact that it looks like it's not quite going to make it.

I measure my success by my level of integrity. I've never sold-out by compromising my artistic values. So what if the king of France

doesn't own any of my pieces?! I love selling artwork to people who really like it.

When you get older, it's great to discover that all of those panicky things you worry about when you're younger get ironed out—it all

comes out in the wash. Young women should try to see the big picture and choose their battles—don't sweat the small stuff.

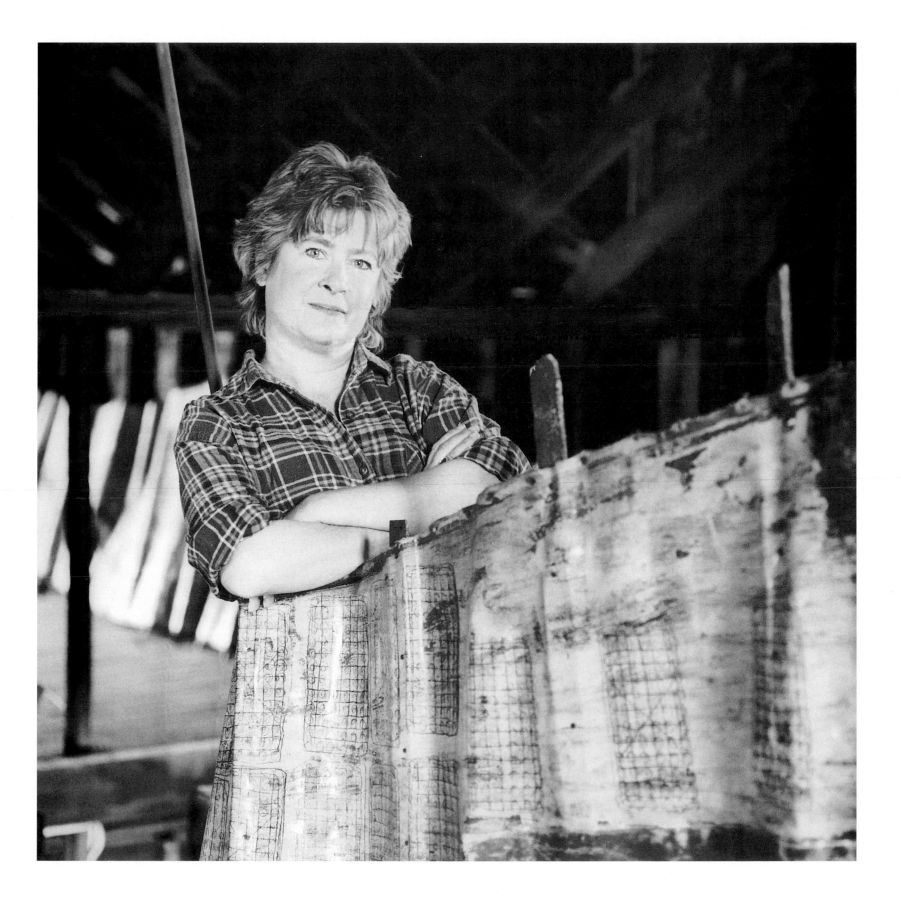

DEBRA FERNANDEZ

BORN: 10/18/52

As a dancer I rely on my body, so I am attuned to its changes. But I believe we are beings of body, mind, and spirit.

When skin and breasts start to sag, I think the gravity showing up externally is also going on internally. As people start to

lose their spontaneity, their attitudes get locked inside their body. That's why it's good to stand on your head!

Yoga, dance, and other forms of movement help keep you fluid and open.

I love teaching dance to beginners. They arrive all stressed out, and most of them have never really dealt with

their bodies before. I'll put on some Brazilian music and get them leaping and jumping around. When they leave

they're sweaty, flushed, and smiling. It's a thrill and a gift to see that transformation.

Performing is not the same as choreographing a dance for someone else. When I perform, it's more immediate.

I become very centered, focused on both my inner and outer self. When I choreograph, I shape the dance to fit other people.

Dancing and seeing my dances brought to life on stage are my greatest joys.

Forty is a real turning point, and not just in your head.

As soon as you become aware that you're starting to lose something, it becomes more precious to you.

I have to admit there's a part of me that wishes I still looked like I did when I was younger.

The decline of the instrument is tough.

I've been fortunate to meet older women who are full of life and totally comfortable with themselves.

It's a gift to look at someone who's managed to age with an open heart. These women haven't had face-lifts; they're not thin.

They look magnificent because they're in their own power—their inner light shines through. Pulling up the skin on your face

does not make you look beautiful. When a woman is really present, on and all there, she's radiant.

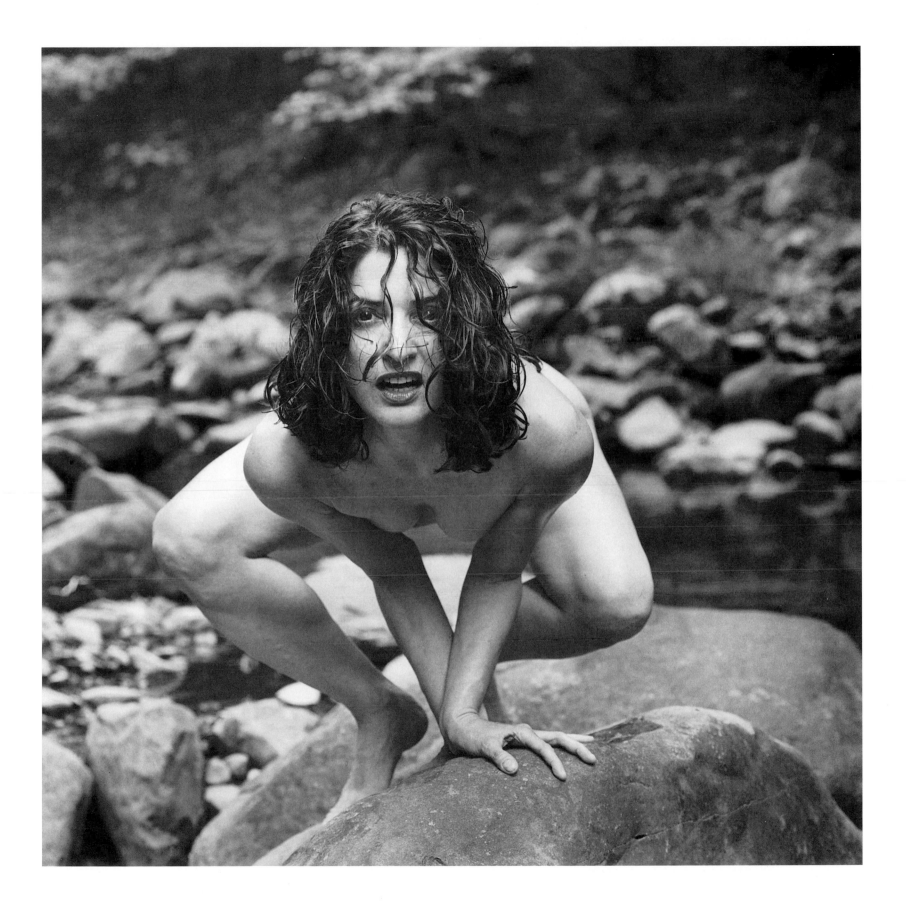

MARSHA R. BASLOE

BORN: 2/9/52

I feel feminine, but I don't think anyone would describe me that way. I'm the type people usually call "a little dynamo."

When I was young, I wanted to be a lawyer. My parents wanted me to be well educated,

but there was an unspoken rule that "nice Jewish girls don't become lawyers–they marry them." I got the

subliminal message that you go to college, find a nice man, and let *him* take care of *you.*

Ironically, I ended up being the caregiver in my family for quite some time, putting my own needs aside.

My parents were aging and there were several family illnesses that took precedence.

Even when I went back to work full-time, I spent many years feeling like everything was up to me: the house, the kids,

the relationship with my husband, the nursing, and anything else that needed to be tended to.

I finally reached a point where I didn't want to neglect myself anymore. It was a relief to admit that I couldn't do it

all alone and ask for help. I learned it's OK to be vulnerable, that vulnerable doesn't mean weak.

I grew up in a household where my parents were always doing volunteer work.

I believe strongly that if you live in a community you must help give something back to it.

For the past five years I've been working with at-risk youths in a collaborative effort between a college and an inner-city school district.

When the program first started, I was it! We now have a full-time staff of fifteen and an annual budget that's grown from

$50,000 to $350,000. There are 225 kids in the program, which allows me to express my caretaker, maternal nature.

Now I'm embarking on a time of new discovery. When I was younger, there were parts of me that I closed down.

I'm starting to get back in touch with myself, feeling the full range of my emotions and being more open to my sensuality.

It's new to me. I'm not all that comfortable with it yet . . . but I like it!

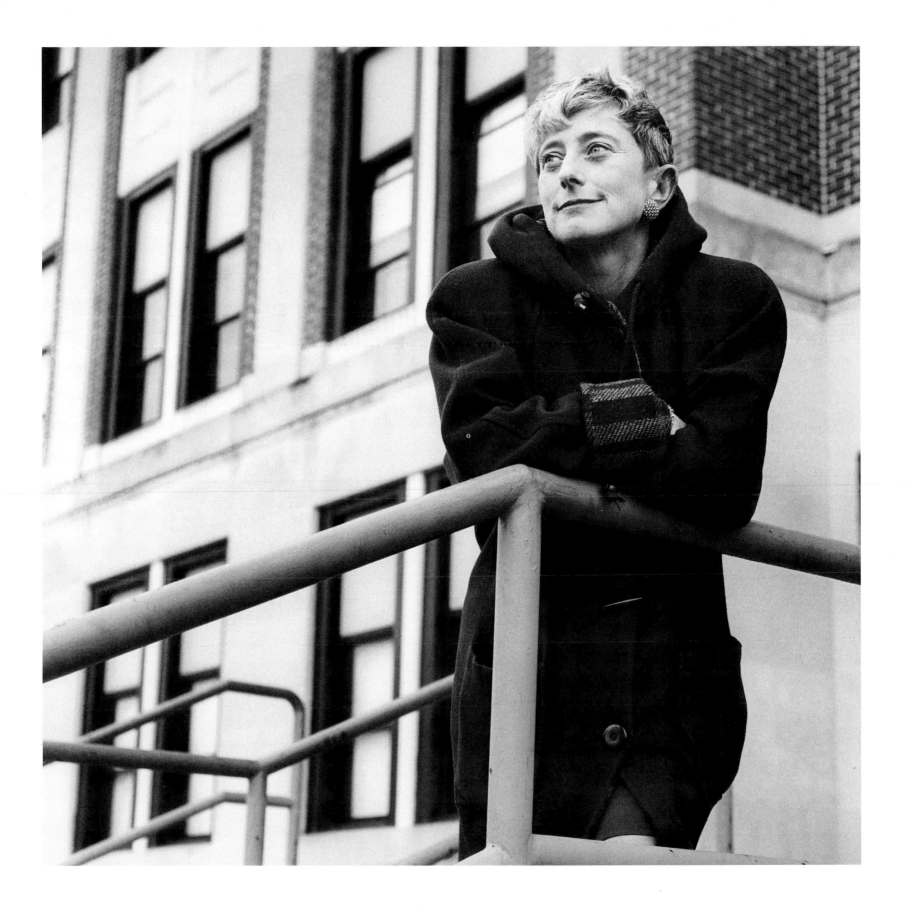

T H E L M A P R I C E

BORN: 5/25/54

Everyone has a cross to bear in life. Mine's been a lot heavier than most.

I had a very traumatic childhood. By the age of nine, I had ulcers. The doctor gave me tranquilizers and said,

"These will make you happy." This made me believe that the only way I could feel happy was to take drugs.

In my twenties, I was an active addict attending college and working off and on.

By this time I had one child and was trying to be a good mother, too.

My addiction progressed and by the time I was thirty-five I realized my choices were to get off drugs or kill myself.

I didn't want to die, so I went into detox and lived in a residential therapeutic community for one year.

I hoped that if I got off drugs maybe I could do something with my life.

I've been substance free ever since.

I was told in September of 1986 that I was HIV positive. I was pregnant with my second son

and, through the grace of God, he didn't contract the virus. Another surprise is that I'm still as healthy as can be.

I've never been on any type of medication and if I had listened to doctors and the media I would probably be dead by now.

Today I am a HIV/AIDS activist and a substance-abuse counselor at the residential therapeutic community where I recovered.

I want to give back something of what I got and work with people to help them realize that life is worth living, that there is hope.

If I had a chance, I would have changed my whole existence. What kept me going was seeing a light at the end of the tunnel

and hearing a voice inside me that said, "Never give up."

I'm glad to be able to see another day. I'm blessed that I have lived to see my granddaughter, who is my joy. I accept myself for where I am,

where I have come from, and where I must go. I'm proud to be an African American woman, and I plan to age with grace.

I'm now the best I've ever been in my life.

I've learned to look at the trials and hard times I've experienced as doors of opportunity. I can now see that the difficulties

I went through in my thirties brought out the best in me, developed my character, and helped me leap into my forties.

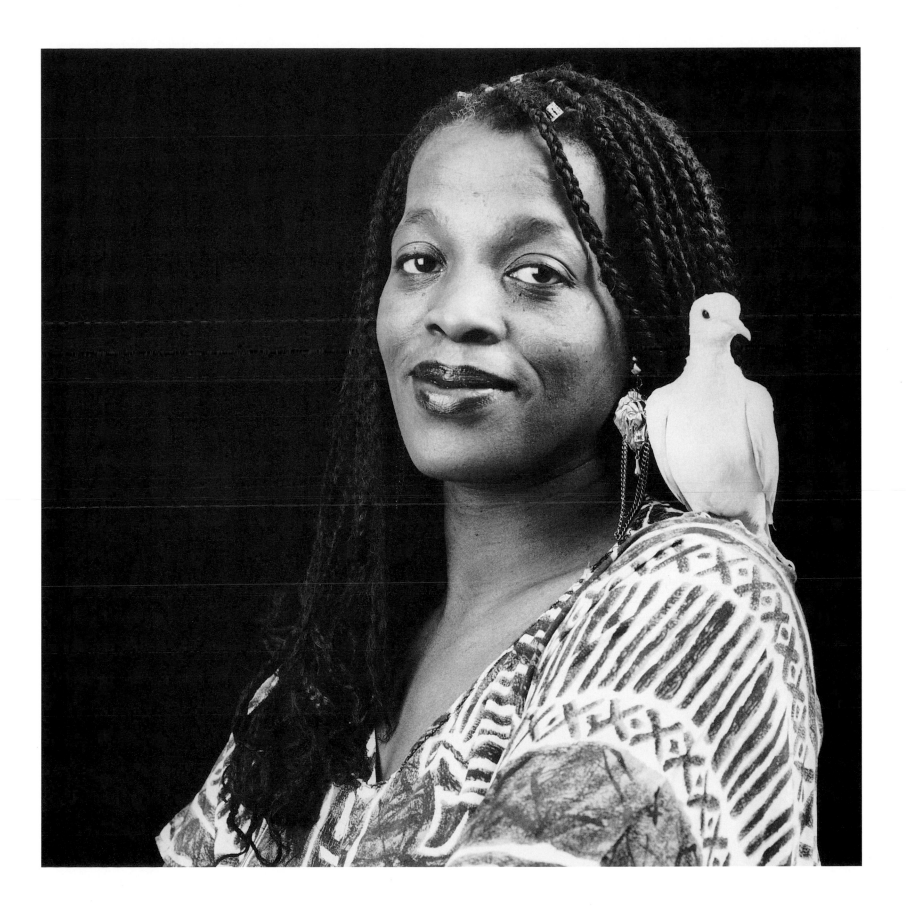

LINDA V. GADUS

BORN: 5/22/52

I'm 5'2" and I weighed 115 pounds when I got married. The weight came on gradually—by my mid-thirties I weighed 190 pounds

and was miserable. When I moved into size twenty-two jeans, I decided I really had to get a handle on my weight.

That's when I turned to God and began an exciting spiritual journey.

I had read about a biblical-based weight-loss program founded by a dietitian in Tennessee.

I contacted her and started the program at my church two years ago. Now I'm a size twelve—and still losing!

I continue to work at growing spiritually, which is the key to staying strong mentally and physically.

Stress, fear, bitterness, resentment, and an unforgiving attitude destroy life.

I've learned the only way to overcome these things is through a strong relationship with God.

As a kid, I was a quiet, serious honor student who majored in accounting. In high school I would have been voted "the person least likely

to ride a Harley!" Now I fantasize about riding my Harley to my next high school reunion and freaking everyone out!

I've always loved riding behind my husband on his motorcycle, but never thought I could handle it myself.

When I was ten years old I nearly drove my cousin's dirt bike through a garage door. But at age forty-three I took a motorcycle safety

course and rode my own customized Harley-Davidson Sportster for the very first time. I did it! I amazed myself.

I still get a rush every time I climb on my bike.

I don't feel forty. I feel great. I've learned so much and I'm happy with the person I've become. I have so many goals and dreams.

My future is filled with hope. I'm the best I've ever been.

I'll be even better at fifty.

The first time I saw an exhibit of prints in a gallery, I felt an incredible, strong wave of emotion.

It was so overwhelming and naked that I was worried someone would notice. For some reason, I've always had an affinity with

the way prints look and the magic of the process.

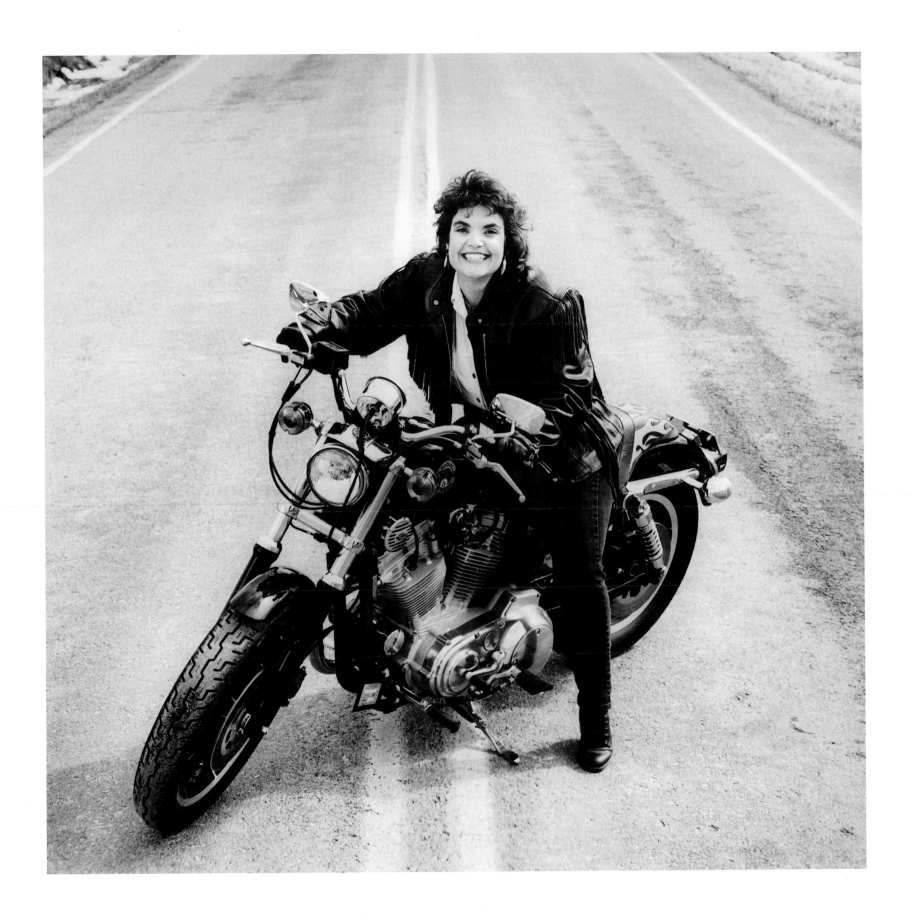

When my two children were babies, I made linocut prints on the bedroom dresser. I began working on my Bachelor of Fine Arts

in printmaking at thirty-one, and received my MFA (Master of Fine Arts) when I was thirty-nine.

It was a lot of work to keep a rhythm because I was raising my family, working part-time, and going to school.

I discovered that when you want something bad enough, the drive keeps you going.

Because I was older, a woman, and a mother, I was not seen as serious as other students. Teachers assumed

I was just dabbling, so they dismissed me and put me in this box, which ironically turned out to be a good thing. Before that, I was the

type of person who needed someone else to validate me and tell me I was OK. I had to learn to believe in myself.

Once I was advised to take off my wedding band before going to a gallery to have my work reviewed.

I didn't see what being married had to do with my abilities, and I doubted a man would be treated the same way.

Now when I feel patronized or pigeonholed, it pisses me off big time. Actually, it's a great motivation.

As a teacher, I'm interested in my older students. The ones who succeed are the students who understand that

just because you're older, you don't necessarily have all the answers.

When you're a beginner, you're a beginner, no matter how old you are.

All printmaking equipment is designed for a man—it's physical to operate, take care of, and get around. Oddly enough, that's part of the

attraction for me. It involves my whole body and being, physically, mentally, and spiritually. It's a real Zen kind of thing.

Printmakers are the truck drivers of the art world.

But I can't think of a nicer, better way to live: sharing what I love with other people and creating my art.

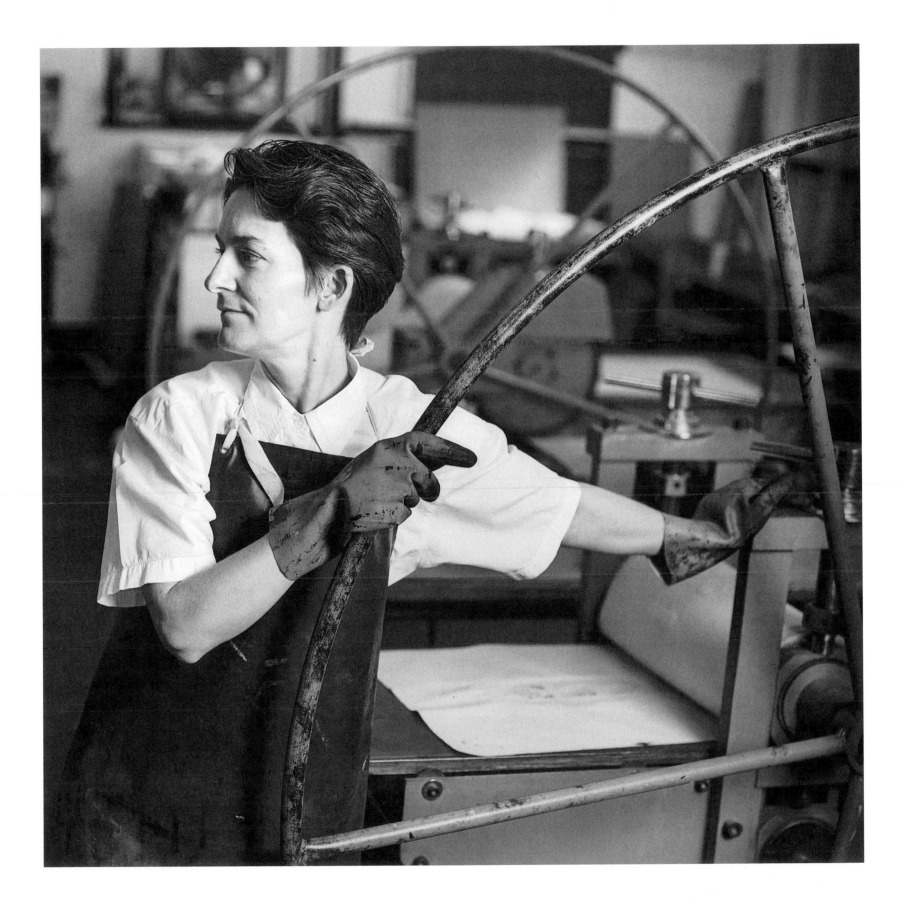

Unfairness and injustice have always driven me nuts. Not just injustice to me, injustice to *anybody*, particularly women.
I write social satire disguised as a reader-friendly page hoping to change things.

The double standard regarding aging is a very painful reality for most women in America. A forty-year-old man is just hitting his prime
while a forty-year-old woman is considered over-the-hill. It's insulting nonsense!

I didn't even know who I was until I was almost forty. I've never felt more sane, more focused, and more creative.

This doesn't mean I don't feel devalued in a society when youth and beauty for a woman are much more important than
talent, insight, wisdom, and humor. In this country if you look for self-esteem on the outside you won't find it.
You have to learn an internal set of values.

Our culture tells women that romance in a relationship should make up 90 percent of our lives, to be preoccupied with things like
"When will he call again?" or "What did he mean when he said that?" I've learned I prefer a *good* relationship that supports me so that
the drama is cut down to about 10 percent of my life. Then I have all this other energy—so what am I going to *do* with it?

Most of us are programmed to do what is "practical" and "realistic." We're not encouraged to follow our dreams. The most courageous
thing I ever did in my life was to have enough faith to explore my creative self. I was very frightened but I bit the bullet. I had to fight the
demon that asked me every day, "Who do you think you are? You can't write a novel." But I did. And I've never been happier.

People call me "feisty" and that's when they're being polite. I try so hard to be pleasant and cooperative because I like to get along. But
women with views are seen as troublemakers. I've been called difficult my whole life, so I guess I am.

My girlfriends are very important to me. I need their strength and camaraderie. They make me laugh and they cry with me. We help each
other persevere with humor. I love women's salty, down-to-earth world view.

I've done my best to stop worrying about how I look and worry much more about how I *feel*. Instead of being pretty or stylish,
I'd rather be vital. I want to have the energy to dance on my porch for a lot of years to come.

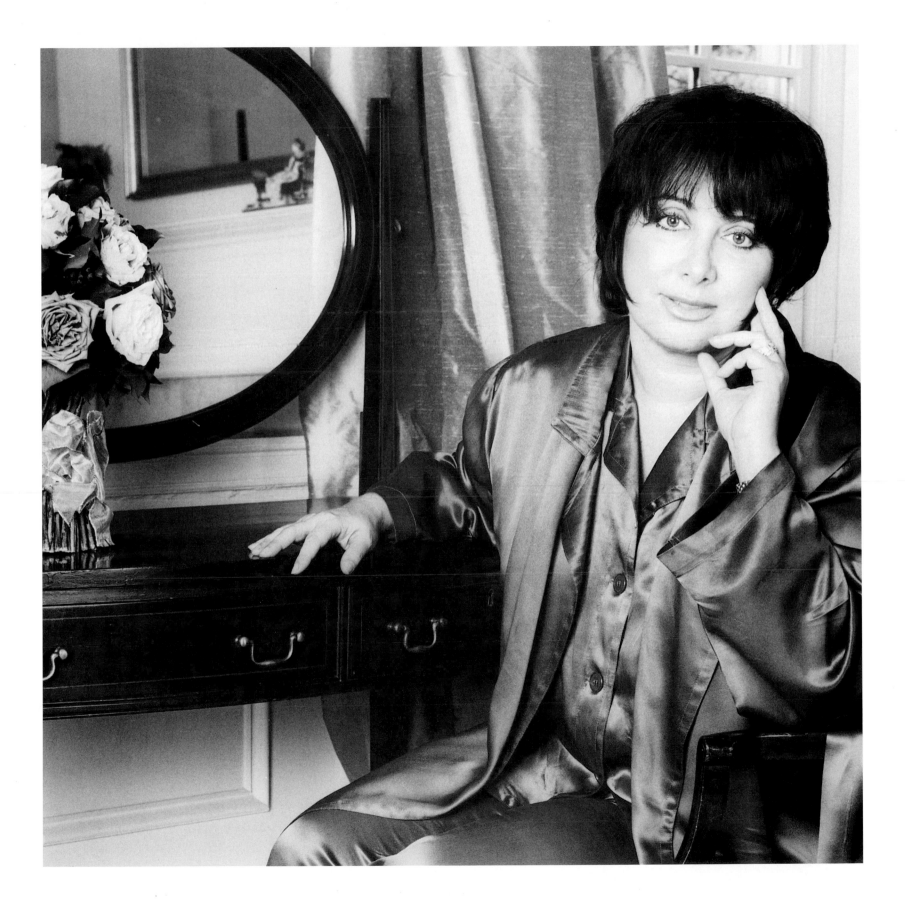

G A I L S T R A U B

BORN: 1/14/49

Aging takes me inward and invites me to be more caring and gentle with myself.

I feel I need to take really good care of my body now—love it, exercise, eat good food, and have lots of fun.

The emotional and spiritual wisdom I've gained greatly outweighs the challenges of menopause.

When I was younger, there was a part of me that wanted to be a man. The desire to be a male was not physical—I didn't want to

live in a male body. It was a political urge instilled by my early feminism. I simply wanted to have an equal chance.

Now I love my deep feminine parts. As a woman, I relate to Artemis, Greek goddess of the moon and hunt.

Artemis types are usually strong feminists and women's women.

I believe in making female friends a high priority and supporting your sisters. I've been in a women's group for sixteen years,

meeting several times a year with four other women. Some kind of cosmic force must have put us together because we are so completely

different. We're a microcosm—we agree, we disagree, we fight, we make up, we celebrate, and we nourish each other. Our little pocket of

diversity is a great way to practice what the world needs today: understanding, nurturing, and compassion.

When I met my husband seventeen years ago, "empowerment" was not a word you heard very often.

We immediately knew that our lifework together would revolve around empowerment in every sense of the word—in the workplace,

in relationships, and in one's inner spiritual life. We were committed to teaching people how to manifest their vision.

My husband and I had a lot of grace and guidance when we started our business: Empowerment Training Programs.

Working with your spouse is not for the fainthearted but it is definitely rewarding. We both feel very blessed

to have a career that nourishes our souls and makes a difference in the world.

I want to leave the earth a better place for the next generation. Through my work I invite people to

know themselves and know their God, to work hard, play hard, and look compassionately at what gives life meaning.

I encourage students to live their dream boldly and live their life with passion!

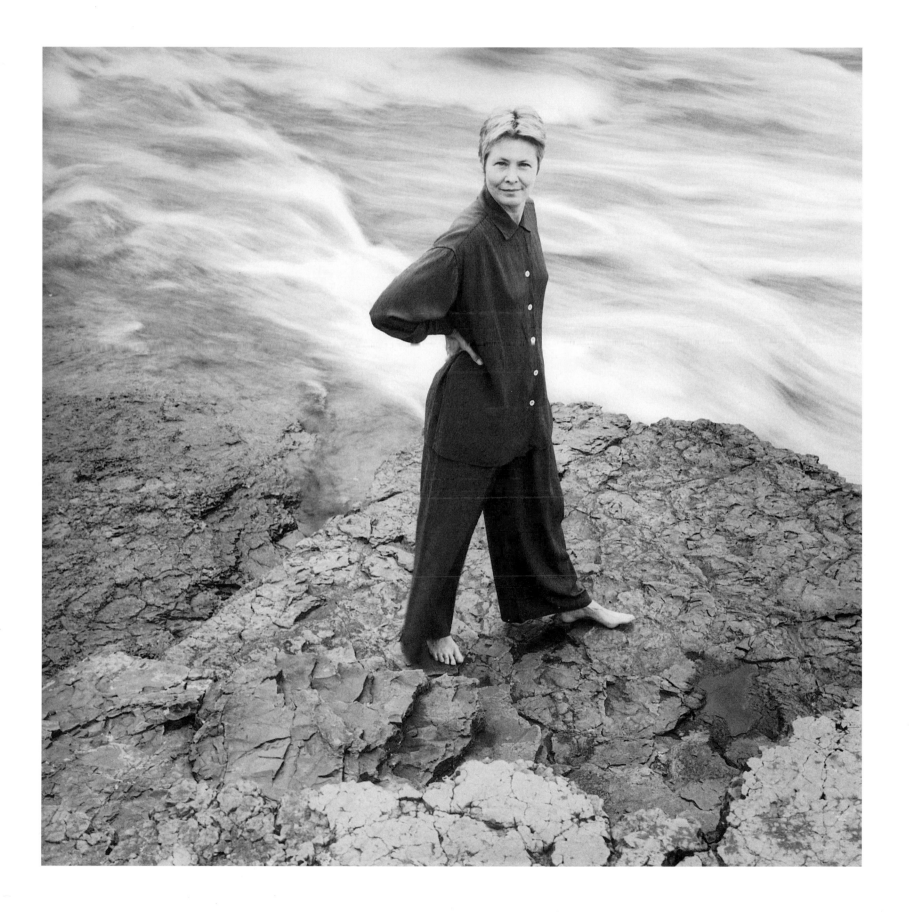

B A R B A R A A N N P E D U Z Z I

Born: 7/25/42

It took me a long while to find out who I wanted to be when I grew up. At age twenty or even thirty

I never imagined myself with the lifestyle I now have. Even if I had, I wouldn't have thought I'd be so content with it.

Going through two husbands and trying to do the traditional Betty Crocker thing didn't work. After I turned forty,

I decided it was *my* turn. I finally had enough smarts to stop trying to please others and just do what I wanted with my life.

That's when I got the nerve to take an untraditional step and learn to drive a tractor trailer.

It turned out that I was actually pretty good at it!

I like the challenge of being a trucker. It also allows me time to work at a regional summer theater company

that I've been involved with since I was in my twenties.

Truckers are a breed apart. We're the last cowboys. There's a real independence to being out on the road by yourself, driving through

beautiful scenery and meeting people along the way. I've almost seen the entire USA. It's like I get paid to be a tourist!

In some ways it's easier being a female trucker—I don't have any "balls" to protect! I can drive, crawl into the motor to fix something,

then go home and cook a nice supper without wondering what the good ole boys think of me.

It's great being a woman—we have all the options.

I like being "a girl" at the right times and appreciate men who can handle an independent woman without being threatened.

I enjoy the wisdom and experience age brings. I feel more secure being myself and doing my own thing.

I have no intention of changing the way I am.

The best way I've learned to stay young is to surround myself with young people and make *them* keep up with *me*. I give myself

every chance to be everything I can be. I try everything that comes along—within the legal limits.

If I'm not having a good time, I'm not doing it!

My husband tells me I'm more sensual now than I was twenty-five years ago. It's great to still feel desirable!

38

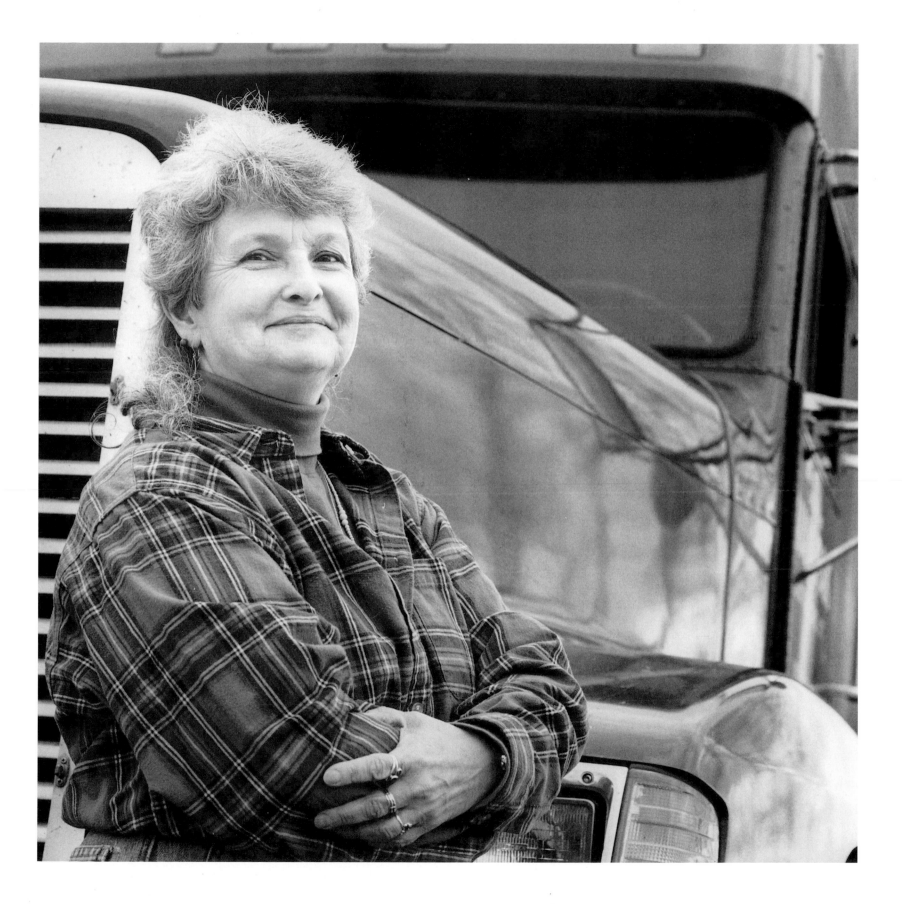

GRACE MARIE ANDERSON

BORN: 2/7/51

I believe you can grow to love somebody more as time goes by. I know my husband so well that I can tell how he's feeling just by looking

at his face for a second. Over time, we've become more sensitive to each other and to each other's needs.

My husband never had Italian food before he married me—his mother had never even made a pot of sauce or spaghetti.

Now he likes Italian food, which I make a lot. I'm Italian, what do you expect? I love cooking. My favorite pastime

is going through my library of cookbooks and finding a new recipe to try.

My husband and I have been married for more than twenty-five years. I feel lucky that we met and stayed married.

I think it would be so very difficult to raise a child alone. You don't just have a baby, it's a life that goes on forever.

Every day there is always something you have to deal with, and it's easy to lose perspective. Someone else there can help bring you back to

earth. And if there's two of you telling your children the same thing, they are more likely to listen.

As the children get older there is more time for my husband and me. I'm finding new interests that I didn't have time for before.

I love being romantic. Sensuality is being able to be feminine without pushing it. You can be sexy without your chest hanging out or your

skirt really short. Femininity to me is more subtle—it's how you use your voice, wearing soft materials, the way you walk.

My husband has taught me to enjoy life, to relax and have fun. I know we were meant to be together and I can't imagine

being with anybody else, ever. It doesn't feel old, worn out, or boring. It's always something new.

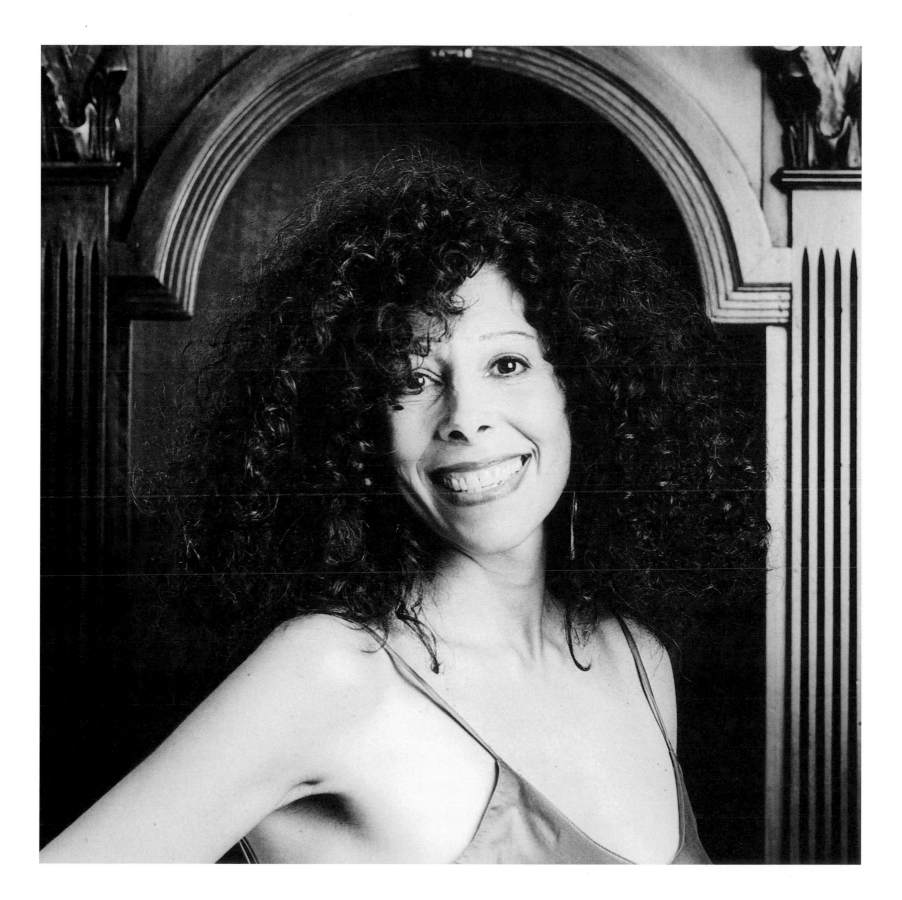

CHARLENE SHORTSLEEVE

BORN: 8/13/50

From the time I was a little kid, I wanted to be older. I didn't like being a kid and I never liked other kids—I'd hang out with adults. I felt as old as the people I was with. Now I feel as young as whomever I happen to be with.

Because of my club, QE2, I'm in with young people almost every night of the week. Wherever I go, I'm almost always the oldest person. My parents keep asking me when I'm going to grow up, but that question has no relevancy. Age just isn't an issue.

I've always preferred basements to being outdoors. On my thirteenth birthday, I decided I did not like light and wouldn't go out during the day. I am completely nocturnal—the rest of my family is normal. I'm just drawn to the ghoulish.

I wore black all the time, even as a kid. In those days, you couldn't get black clothes very easily, so I had to dye everything on top of the stove. My mom would come home and get upset, telling me I was ruining her pots and pans. I've just never felt right in any color but black. At the moment that makes me very fashionable!

I used to spend my summers working in a ceramics shop in the basement of a rectory. It was cool and dark. There were lots of religious statues and everyone always wore black—just like at QE2. I feel the most sensual in a heady swirl of music and art, bathed in black light and fog, with votive candles and vodka.

I like being a woman. Girl-stuff is fun. You get to paint yourself up, wear cool clothes and high heels.

If I weren't a woman, I'd have to be a drag queen.

I love to daydream—I constantly daydream. I have to remind myself to drop in on real life once in a while.

Friday the thirteenth is my lucky day. It's the day I was born. The only time I celebrate my birthday is when it falls on Friday. That makes me pretty young, I guess.

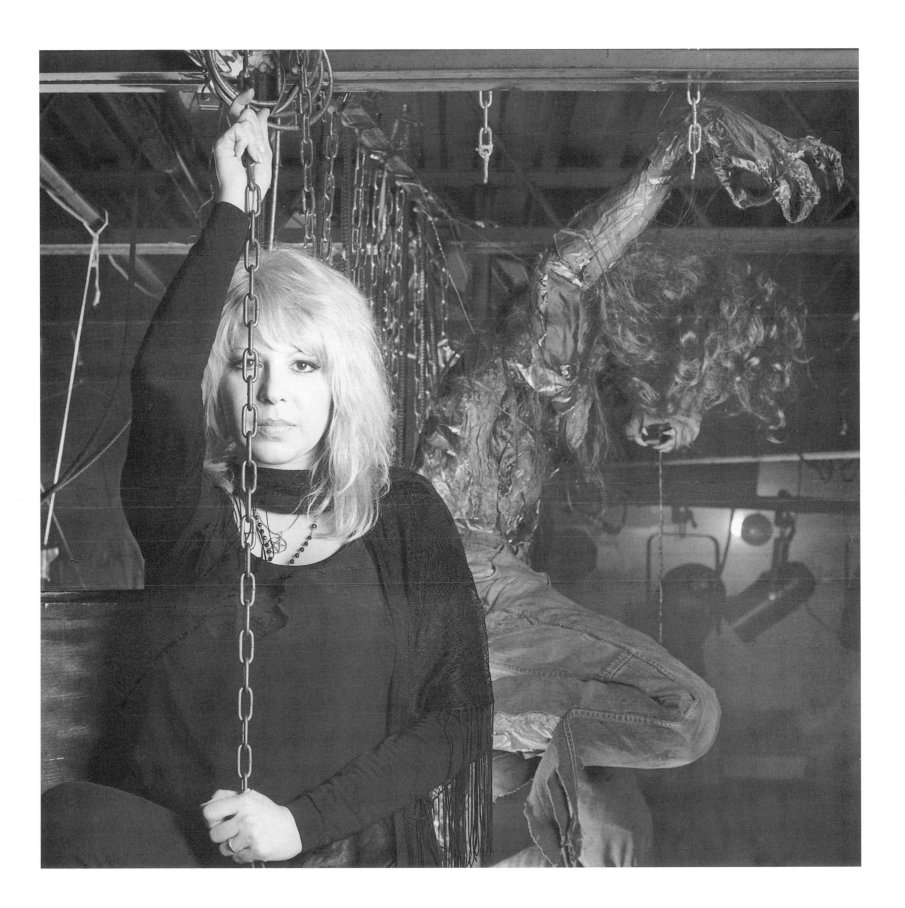

CATHERINE BRUMLEY

BORN: 4/5/51

One of my favorite tai chi metaphors is, "Embrace tiger, return to mountain."

When you embrace tiger, you embrace life's challenges as gifts—whether they're wrapped in pretty paper or not! Instead of fighting, running away, or ignoring an experience, you embrace the whole thing as a learning opportunity.

"Return to mountain" means coming back to your center, your core, that place of strength and serenity. From there you can move forward again.

This principle is so pure and simple. It's given me a sense of safety because it is constant but not fixed. Instead of being afraid of change, I can see it in a positive way, as the breath of life. I'm better able to relax and trust that I'll take the next breath, and that whatever is happening is OK.

One of the hardest lessons for me to learn has been to move on in my life. It's easy to be trapped—in an unhappy relationship, an unfulfilling job, anything. I've had to have the courage to jump off the cliff. I always figure that even though I don't know what's going to happen, I'll find out. And I have.

I hope what Gloria Steinem and women of our generation did will be appreciated and built upon by younger women. We're pioneers who've had to make it up as we go along. I remember being a young woman and going to the movies alone, which just wasn't done. I felt like I had twenty arms and fifty eyeballs—but, by God, I was going to go to the movies by myself!

I feel blessed to have had the opportunity to contribute to a positive future for myself and for other women. We're living in a time when so much is possible. Women are in the position to create who they want to be and do what they want do.

When you feel good in your body, at any age, you have a youthful energy. As you get older you don't care as much about being proper—you can be as playful as you want and kick more butt!

I want to be a wise old lady, a feisty old broad. I plan to thrive in life, not just survive.

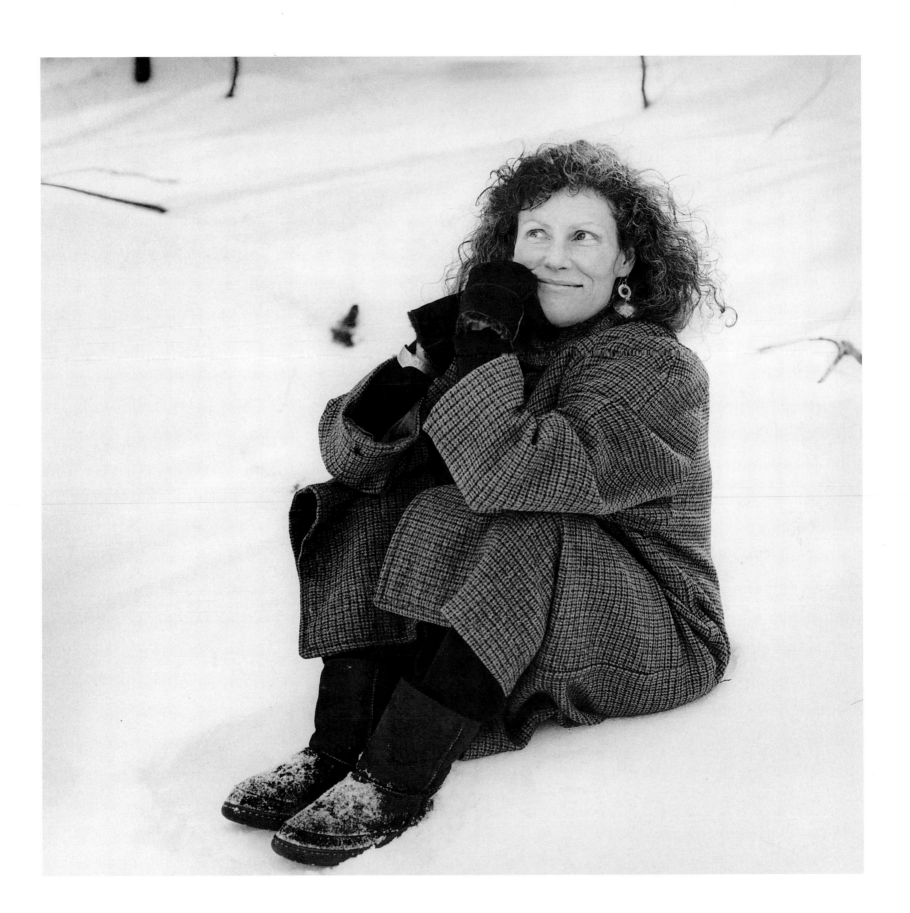

BORN: 4/28/57

I'm in quite a phase—I just turned forty and am faced with negotiating a divorce and being a single mom in a new career.

Life is so crazy right now; my brain feels like it's bursting. I'm looking forward to the future, when things start to settle down. In the

meantime, I've gone through a lot of healing and am feeling better than ever—happier, more confident, and more optimistic.

When I was in my twenties, I felt pressured to get married and do what I thought I was supposed to do:

cooking, gardening, decorating, mothering, entertaining, and volunteering. From the outside it looked like the life of a "glamour wife,"

but it didn't fulfill me. By the time I was in my thirties I felt completely out of touch with myself.

After forty years of feeling out of sync, I now have a real sense of direction. It's a time of self-discovery, unearthing my inner resources,

and tapping into my strength. I'm reclaiming my adventurous side and going places so fast it's hard to keep up.

As a single mother, my children and their emotional well-being are my top priority. I also feel blessed to have a career in publishing,

which combines two things I love the most—books and creative ideas. I still have the same amount of energy I've always had, plus

some newly discovered resources. I'm hopeful that the future is full of new opportunities for love and adventure.

I used to be ambivalent about my looks and was uncomfortable getting attention because I was attractive;

I especially resented being treated like a sex object. It was an issue because I didn't feel like I was taken seriously, as an intelligent human

being—I even thought about getting faux eyeglasses. Now that I'm older, I am treated like the multidimensional person I've always been.

What could be better than entering a new stage of life where anything is possible?

I feel like I've been given the opportunity to journey down the path of becoming a timeless woman in my own time.

I intend to make the most of it.

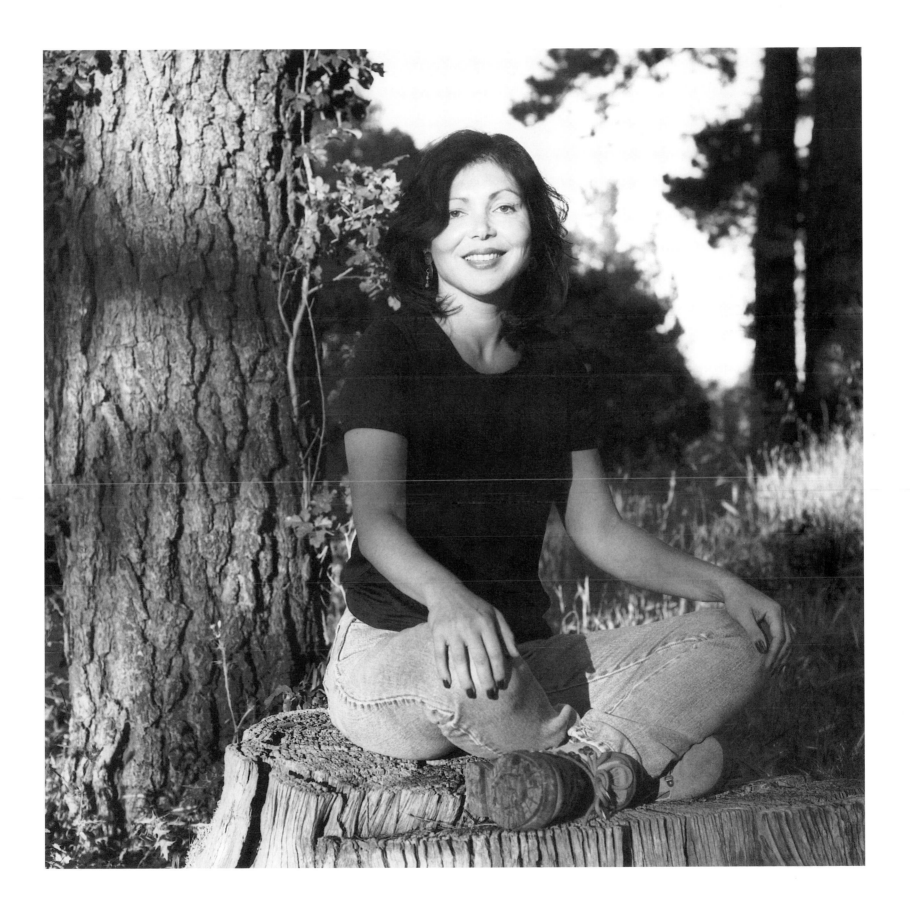

SYLVIA FREEDMAN

BORN: 10/31/41

Life ain't for sissies—everyone goes through difficult times. At this point in my life, I don't have the time or patience for bullshit.

I don't think much about age, and I don't identify with being fifty-six or turning fifty-seven.

But is age really relevant? Someone can be young at seventy-five or old at thirty.

A lot of times I feel like a big kid. I do what I want when I want; I'm impatient, impulsive, and impressionable.

My husband died four years ago in an auto accident. We were very close, and it was a terrible shock.

When you find yourself suddenly widowed, it's a big adjustment.

Having been married for twenty-six years, my husband and I had a large circle of friends. But no one seems to want a single woman hanging around—couples seem to like spending time with other couples. I haven't been dating, either—no one has asked me out yet! So I spend a lot of time alone, and it's a real learning experience. Fortunately, I enjoy my own company and have a lot of solitary interests and hobbies. I don't mind doing things on my own.

I know that traveling alone is a big issue for a lot of women, but it hasn't stopped me—I still love it. Being alone isn't the end of the world, you just have to play it smart and watch out for yourself. I've gotten used to the fact that an older woman traveling solo is treated differently than a single man. You simply cannot walk into a four-star restaurant and get good service—it's just not done. You'll probably end up with a table next to the rest rooms!

Maybe I should care about age, but I don't. I think adulthood is way overrated for the amount of energy that goes into it.

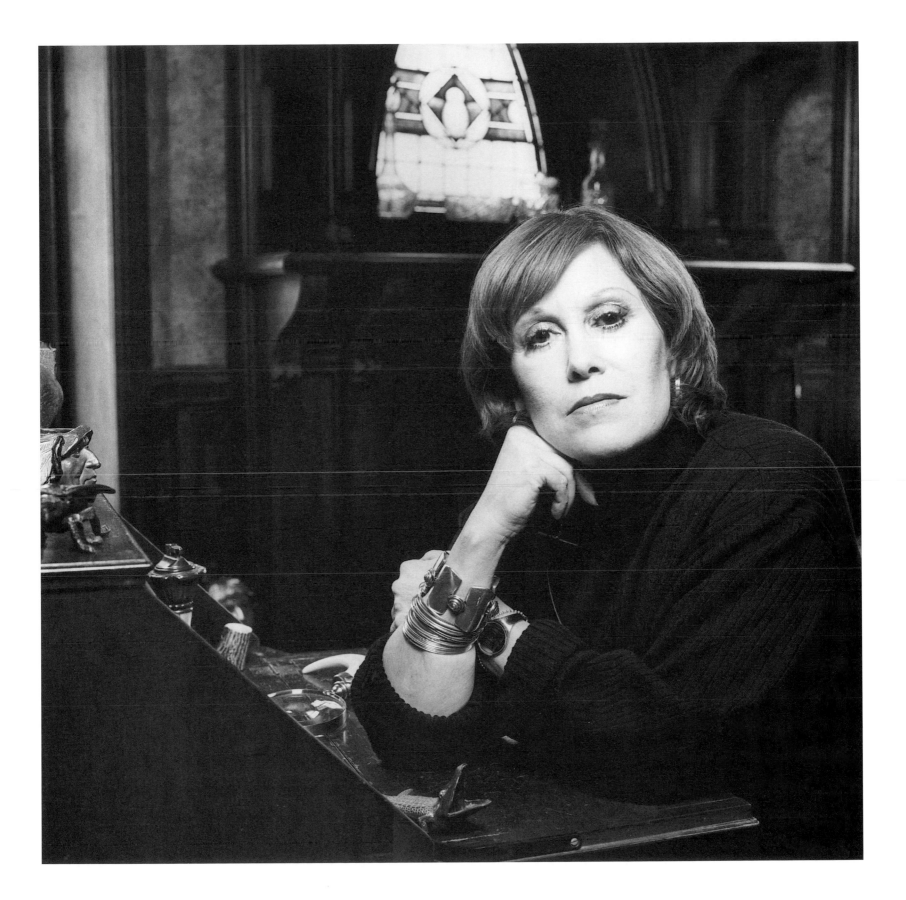

BORN: 2/10/43

I'm not fifty-four in my mind's eye. I'm fixated at twenty-three and will probably never get past thirty-five!

I'm pretty much an open book. What you see is what you get. Now I'm enjoying a confidence I've never felt before

based on what I'm doing with my life and the person I am becoming.

I was a painfully shy, over-protected only child, which was a real handicap. Dancing was my passion, a way to escape.

When I was on stage or in class I felt uninhibited. It was how I let myself go and came out of my shell.

Dancing still transports me. Whether I'm teaching a ballet class or on a ballroom floor, I experience an unbelievable high.

Nothing else I do in life can match the feeling I get when I dance.

My daughter had leukemia and a total stranger saved her life by donating bone marrow. I wanted to pay back the kindness

by doing something in return. After living through the ordeal of my child's marrow transplant, I realized I could do *anything*.

I began my efforts by volunteering at a Red Cross donor center, then, in 1990, I started a marrow donor organization.

I don't know exactly how I did it—it was just an idea I had. I'm so pleased that it's grown steadily and taken on a life of its own.

Every time I find a donor or hear of a patient who's doing well, I feel wonderful.

I've set up my life so that I'm doing everything I love.

I'm making it up as I go along and I like the direction my life is taking. I'm having so much fun; there is so much to see and experience.

I have a sense of urgency to have it all.

I've been through some tough ordeals but I'm still standing. Not only standing—but moving forward!

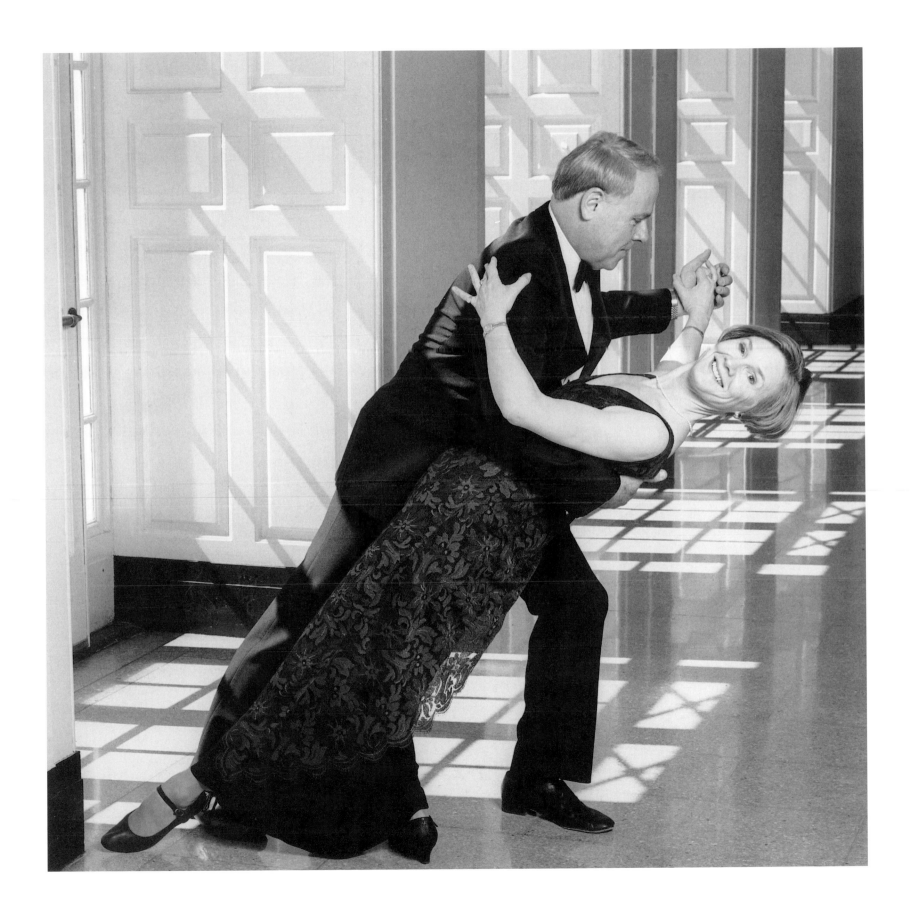

LORAINE M. F. MASTERTON

BORN: 7/6/55

I'm a wiry, bony type and have a tight little core in my body. Most people have an inner child—I have one gnarly inner punk!

I don't know whether I'd want to hold me any closer than an arm's length.

Being a woman is an absolute personal pleasure and a public challenge. I have not had what I would consider to be a graceful life—it's

taken some intense angles and thrusts. It reminds me of a tree growing on a blasted heath bluff. There is a wild beauty about it.

As a Celt, I'm drawn to trees and bushes, the wilderness of the landscape. A bit of earth gives me a sense of place.

I know I'm an enigma. I can be at once uncertain and cheeky and bold and forward.

Melancholy is a real Irish thing. I'm not always clear about who I am, where I came from, or where I'm going. I'm uncertain in my

own uncertainty. On dark days it bothers me, on light days I figure it's just my journey.

As a theatrical person, my driving impulse is the desire to communicate.

I would like to find an artistic way to tell the story of my heritage, my Gaelic roots. To work with it, to work through the turmoil,

and to tell it skillfully will be an exorcism. In the process the audience gets a gift, too.

We should trust older women, actively seek them out. They are our village elders, the true Alma Mater, the mothers of our soul.

Older woman can shepherd the essence of other, younger women.

The smell of the earth and her gardens, a crackling fire, people's own body scent, their own hair (unshaven everywhere),

no makeup, just a healthy glow and clarity to the eyes and skin—these things I find sensual and sexy.

I find warm water very healing. Submerged in water I get voluptuous, softer, peachier. I love being naked in the hot tub, staring up at the

moon, flat on my back. This is where things begin to gel inside. I love it so much I stay until I come out looking like a prune.

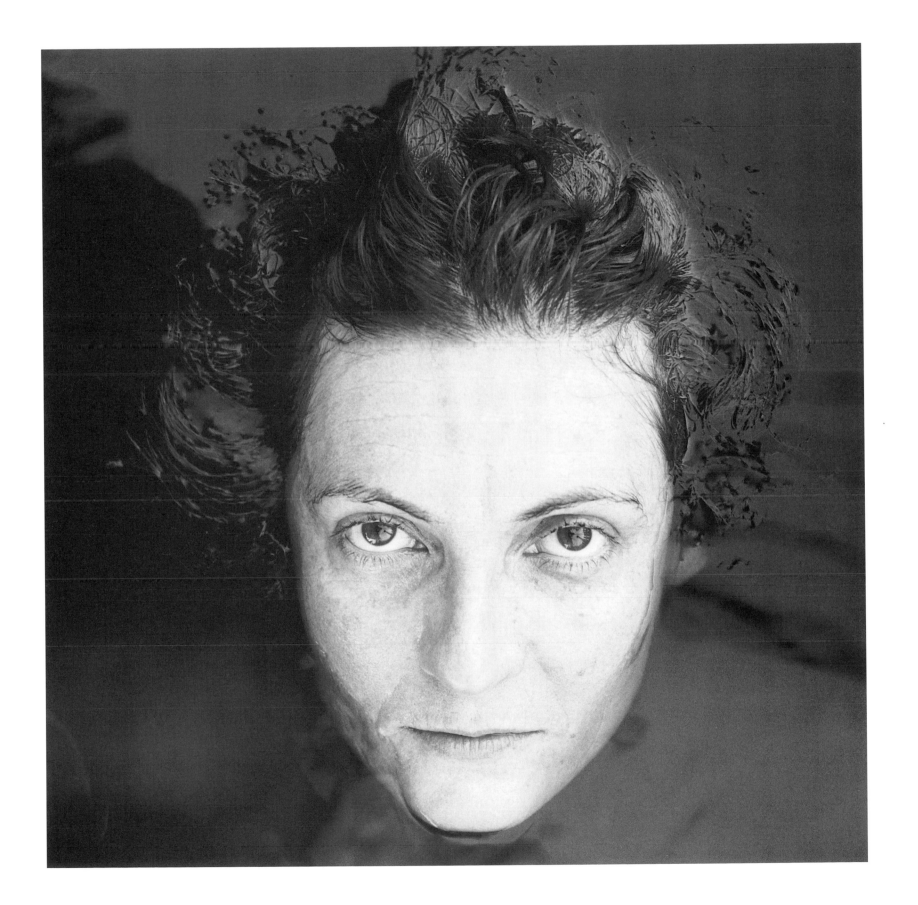

BORN: 5/15/49

I'm amazed to be modeling at the age of forty-seven.

I know we've made progress, but there's still a lot of room for blacks and for women my age out there, both in the media and the public eye. Look around—where are we? There's very little representation. Through modeling, I hope to be a presence and a good role model, especially for young blacks. I feel like I'm doing something that may make a positive difference.

Aging has become an awesome journey since I made certain connections with myself. I paid lip service to the idea of taking control of my life but I didn't really know what it meant until I got older. I've discovered it's a powerful, positive thing—to take responsibility for myself, to be what I want to be, and to do what I need to do in order to feel fulfilled.

My childhood experiences kept me humble—they still keep me humble!

My mother died when I was eight and I was raised by my grandparents on a farm in Virginia. I'm sure my stories rival any of those our children read about from the "good old days." All of us worked very hard, filling bushel baskets with vegetables picked in fields that seemed to go on forever, as far as the eye could see. I was only five years old the first time I drove a tractor.

Yet even in the midst of racism and poverty, we were rich and I always knew I was really loved.

It's wonderful to feel sexy and be open about it. I don't mind it a bit when I get whistles from men on the street.

I usually turn around and say, "Thank you. You're so kind." It's funny to see their jaws drop. But my reaction is truthful because I don't take it for granted when someone appreciates the way I look. They are paying me a compliment and it makes me feel good.

Getting older is wonderful. I wouldn't go back or trade it for anything. I went through some tough times, but once I got to the other side it was like having a baby—I forgot the pain of birth and felt the joy of renewed life. I'm still growing and learning.

I'm not just a work in progress—I'm under construction.

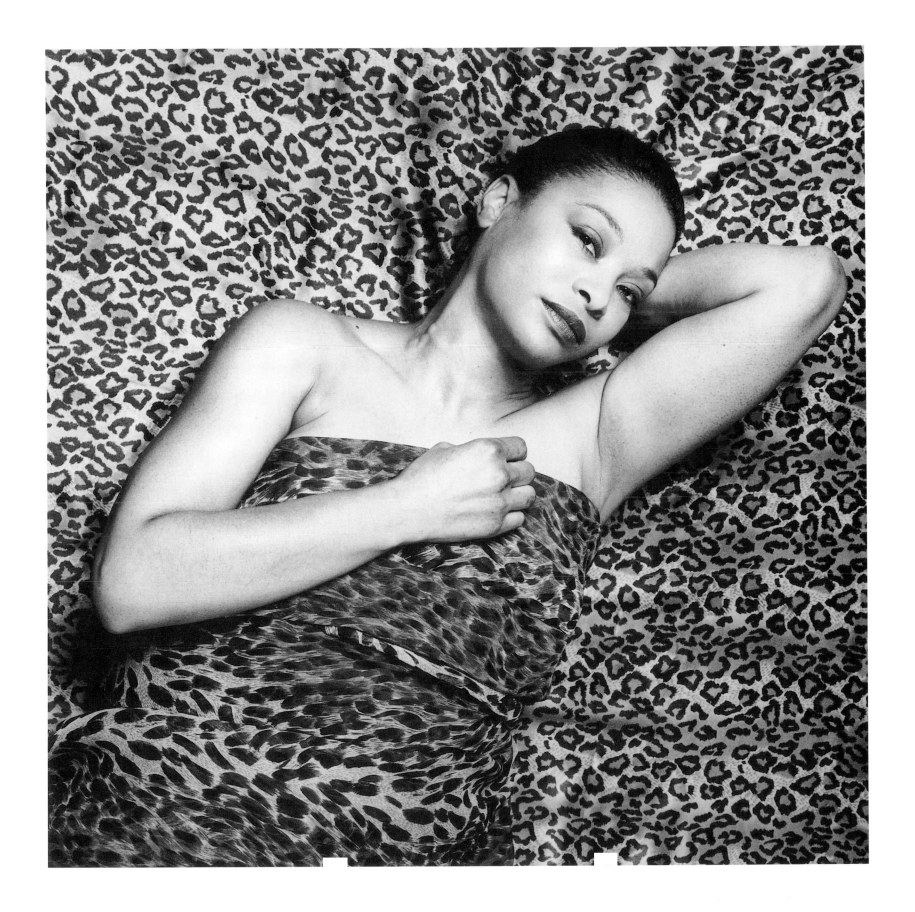

J U D I T H R O T H

BORN: 6/15/38

My sense of style has developed over a period of years.

For the same nickel, I don't want to buy something you see all around. I'm not thirty anymore, and I don't have to look like I am.

It makes me feel good to wear what I like. I've never catered to what others think.

I enjoy being a woman tremendously.

I know my good points; I know my bad points. I don't put a huge emphasis on either—I work with what I have.

Materially, there is very little that I need. I could be very happy with a simpler lifestyle than I've led.

I've always appreciated the fact that I never went without and have been comfortable since childhood, but that's not a priority for me.

I find myself withdrawing when someone just concentrates on the material. If they're status conscious, I'm not interested.

There are so many other things I'd rather focus on.

The loss of my father when I was entering college helped me realize what's truly important in life, where materialism fits into

the scope of things, and what I expected of myself and others. I became very rational and clearheaded about my priorities.

It took a while for my positive, strong, self-determined side to develop. Being strong and sensitive means

being able to act on my feelings with assuredness rather than selfishness and not let my strength overwhelm me or anyone else.

I'm making room for the next generation, for my daughters. I love seeing them blossom into womanhood.

I enjoy doing volunteer work for grassroots organizations related to health, animals, and the arts.

Giving from your heart and soul is more important than giving in just a coin kind of way.

If I lose the joy of true giving, I will have lost everything.

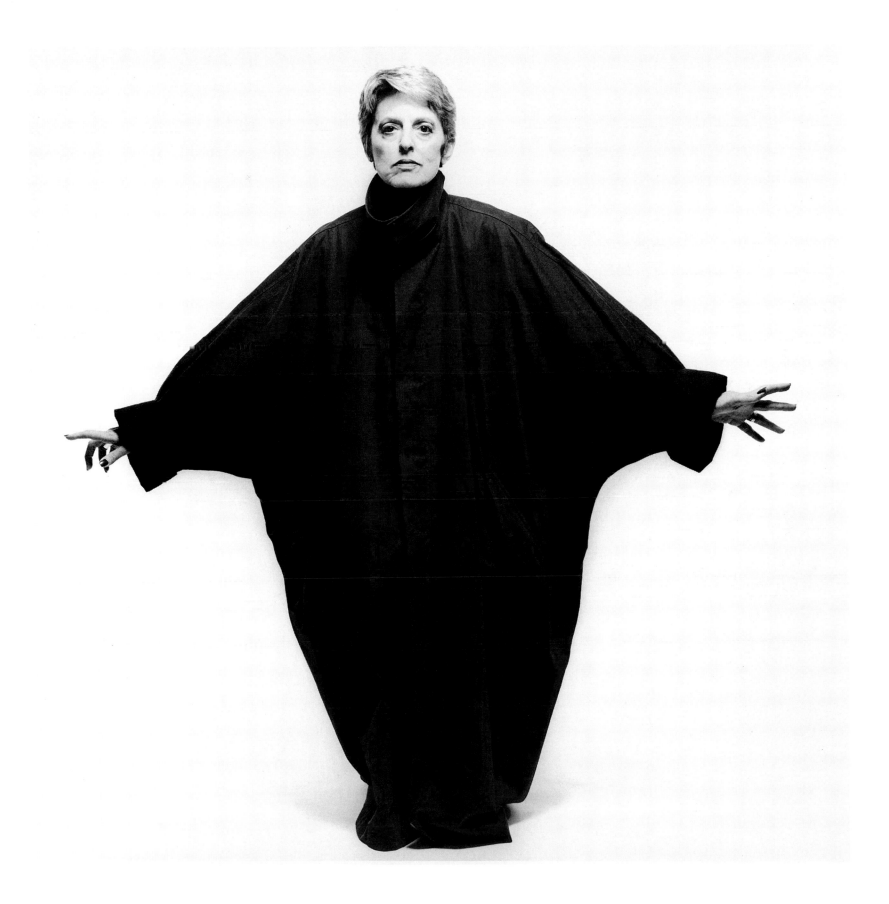

RENATE BONGIORNO

BORN: 10/23/37

You had to be a man to be credible in my family. My mom was an anti-role model—an example of

how *not* to grow up to be a woman. She was sweet, gentle, and caring, but she was totally under my dad's thumb.

He gave her an allowance, even when she worked; she never drove a car, never wrote a check, never paid a bill.

I grew up in the conflicting atmosphere of the 1950s, when the main focus was "to keep the little lady at home."

That's not how I wanted to live my life.

Even the fashions back then reflected the oppressive, repressive attitudes—panty girdles, which were confining and ridiculous,

and those awful, pointy "bullet bras." The clothes were hard, uncomfortable, and constricting, like the cultural position

women were in. Now it's a big day when I have a bra on—I should probably wear one more often!

It feels liberating and wonderful to be older. I'm happily remarried to a man who's twenty years my junior.

I realize there's life outside of marriage. This was a big lesson for me, and it's probably the main reason why I found a great partner.

It never occurred to me to get a tattoo until I first saw Janis Joplin. I had this unexplainably strong, visceral response to her tattoo.

I wanted one so bad, I gave one to myself with needles and india ink. It was a small heart on the middle finger of my left hand.

I had to do it myself because I was living in Massachusetts, where tattooing was illegal.

Over the years, I kept getting tattoos and even met my current husband at my favorite tattoo studio in New York City.

The first Christmas present I ever gave him was a tattoo bracelet of skulls around his wrist. It's the perfect gift because you never lose it

and you never forget who gave it to you.

I've had a good life. It hasn't always been easy, but things always seemed to work out.

If I died tomorrow, I wouldn't say it's been for naught.

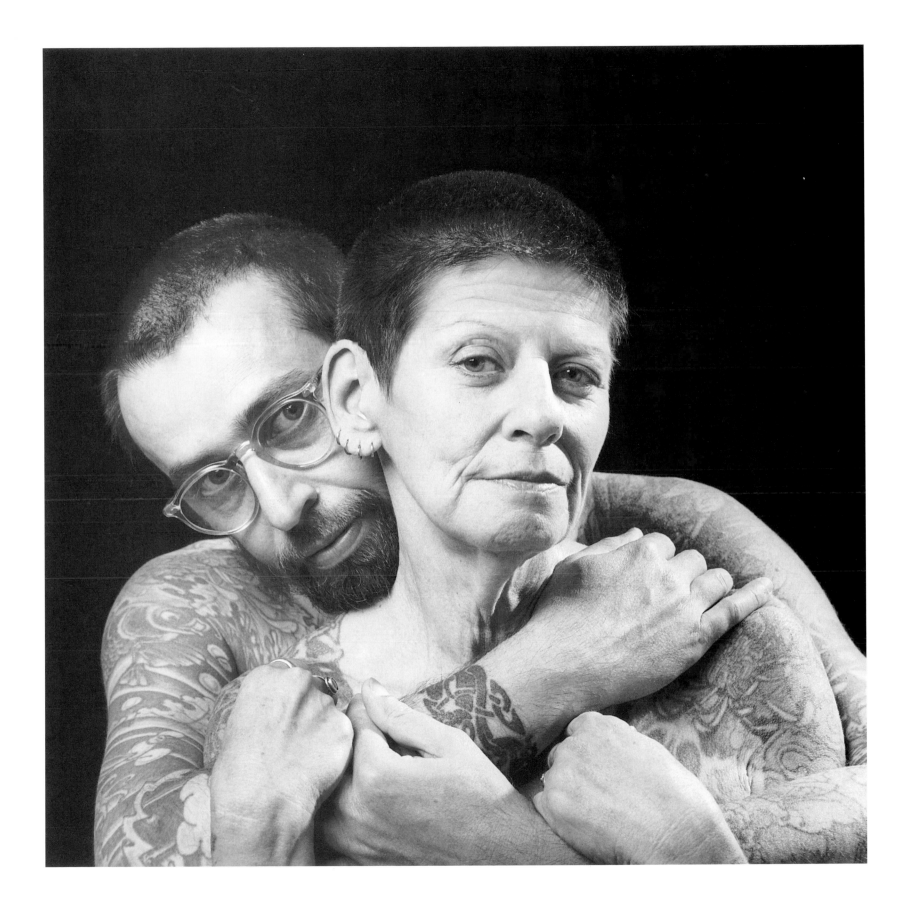

MIRYAM MOUTILLET

BORN: 3/3/56

I'm open to any opportunity I feel would offer a way of growing spiritually and intellectually as a human being. My husband and I both believe that experience is worthwhile, better than a roof over your head. In a way we're still gypsies.

I have always had a passion for my art: dance. Bursts of creativity have come instinctively. I always knew when it was time to turn the page and experiment more. I wanted to be able to touch everything I could and go more deeply into what I was doing—to work unrestrained, to find and explore new truths. I have always done everything I absolutely wanted to do—from touring with Les Grands Ballets Canadians as a dancer to founding the avant-garde dance group La La La Human Steps.

Performing is an art of the moment. The joy is to be fully there, fully present. The powerful and exquisite thing about art is that it lives with you all the time. These moments and perceptions are so engraved in your body experience that you can recollect them. If you are a person who has this sensitivity, it is like you're in touch with everything: God, the universe, another dimension.

I have led a very gypsy life. This is the way when you work in the arts field. I've always had a good sense of my own person, my femininity, and my goals. I have traveled a great deal, and so, the entire world is my planet. It is a fascinating place to be, to see, and to learn from. Discovering and living in other cultures has given me knowledge that only experience can communicate.

Aging and death are not issues. When it's time to go, it's time to go. You just finish. I'm not scared of it.

I have a nice skull my grandparents gave me. They called it "Julie." I keep Julie with me now.

It's a good way of being in touch with life and death.

I feel very fortunate. I've had a very intensive life and a wonderful destiny.

I would say to every woman, both young and old, to live fully and with passion; search for happiness and enjoy life—nothing is impossible!

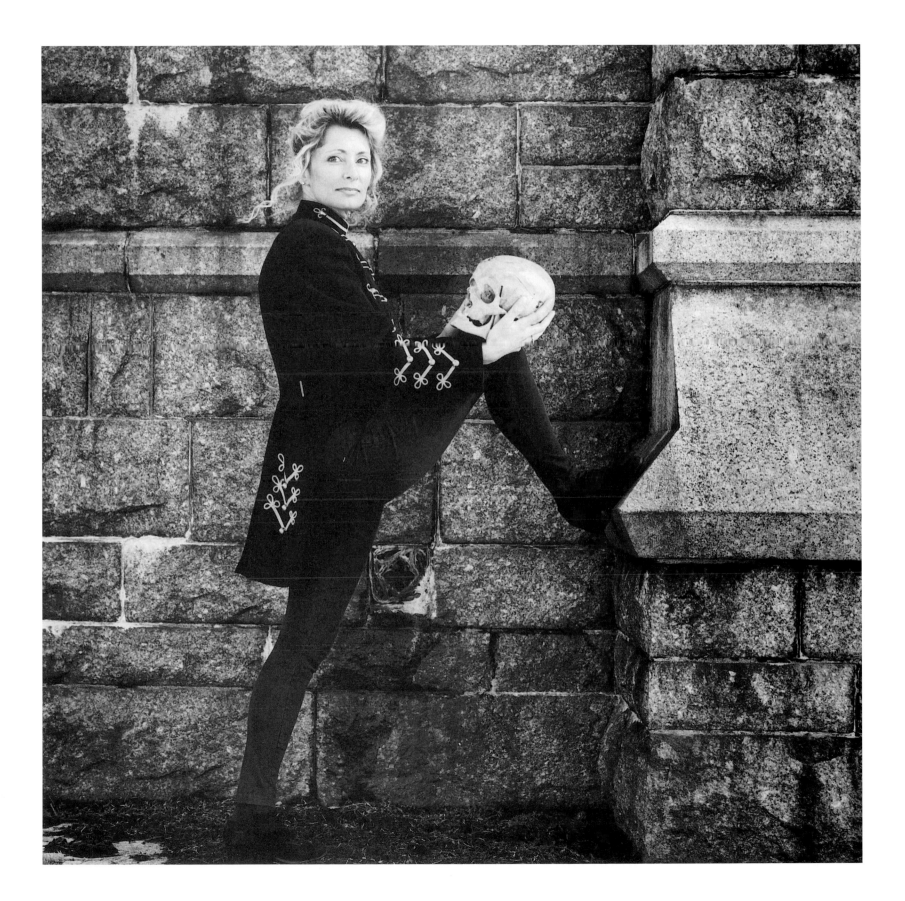

GRACE C. J. ROSS

Women are changing the world—and it's a great thing for all of us.

I find there's something special about churches where women are pastors. The image of the charismatic leader who tells people

what to do is not the best image for the church today. The innate feminine, maternal ability to nurture and care are very much

needed now. It's heartening to see these qualities given recognition and becoming more valued.

Motherhood is great preparation for the ministry because being responsible for a church is, in many ways,

like being responsible for a family. You need to empower people, delegate tasks, gather together for the communion of meals,

and even arrange for things like potluck supper fund-raisers.

From the time I was a young woman I sensed there was something special in the church that I wanted to do.

I had a sensitivity to move in that direction—a call from God, if you will. It was a dream come true that at age fifty-five

I could go back to school—at Yale, no less—and become a pastor.

Even though I preach every Sunday, I've never whipped out sermons quickly.

It used to take me two days to prepare, and inevitably I'd be up until 2 A.M. finishing up! But it's gotten easier as time goes by,

and I have developed my own style of sorts. I try to make the gospel message shine so that it will touch people deeply

and shine in their own lives. Hopefully I say meaningful things that God is pleased with.

I've always thought of myself as a shy, reticent person. But I've discovered that although I am an introvert,

I'm also a strong, enthusiastic woman. I love pastoral counseling and am with people at the important times of their lives: when a child

is born, when there is grave sickness, when a couple is married, and when a loved one dies and the family is in mourning.

It's a great privilege to be part of these moments.

Everyone is blessed with different gifts and graces. God loves all people and has a wonderful plan for our lives.

You can do anything you make up your mind to do. You're never done becoming!

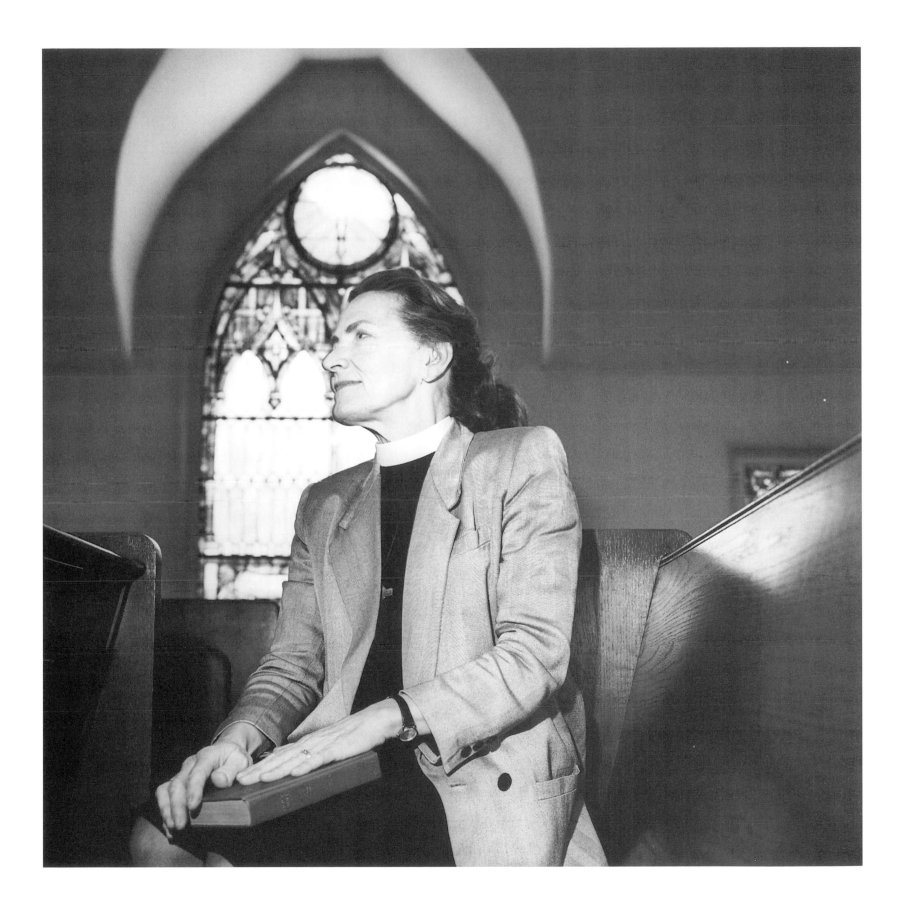

DONA MARA FRIEDMAN

BORN: 1/30/46

The idea of aging was repulsive to me as a child. I remember looking at my grandmothers and thinking, "I never want to be that old. I won't grow gray hair and I won't grow violets!" Violets became a symbol to me of little old ladies who had nothing else to do. It took me a long time to accept violets as a plant I wanted in my house. It's a shame I thought that way. It's sad that society thinks you have to be productive in a way that does not include growing violets. Is growing violets not productive?

I became acutely aware of plants at ten, when I had such a severe reaction to poison ivy that I had to go to the emergency room. I remember thinking, "What is this plant that can do this and why does it have such power?" Later I realized that this severe reaction made me want to look at plants closely and explore their potency. Now it's thrilling for me to be starting a business where I can focus on working with the spiritual essence of plants and their healing qualities and share this with others.

Both of my grandfathers had magnificent gardens. I remember watching my mother's father in his rose garden, picking Japanese beetles off the petals by hand. My father's father had a formal garden that I loved to tour. Both grandfathers encouraged my interest, explaining what they were doing and showing me different techniques. I am proud that I inherited their gardening tools.

The older women in my family were not role models for me. According to them, long hair was something that was for young women—older women cut their hair, tinted it blue, and permed it into tight little curls. This gave me a fear of aging—I was terrified that I would turn into one of them.

My childhood was a combination of love and repression that allowed me to rebel and turn into who I am. I'm not interested in cutting my hair. I'm not interested in fitting into someone else's mode of what a fifty-year-old is supposed to be and do on any level.

What excites me is creating the work I love while enjoying my individuality and sensuality—on my own terms.

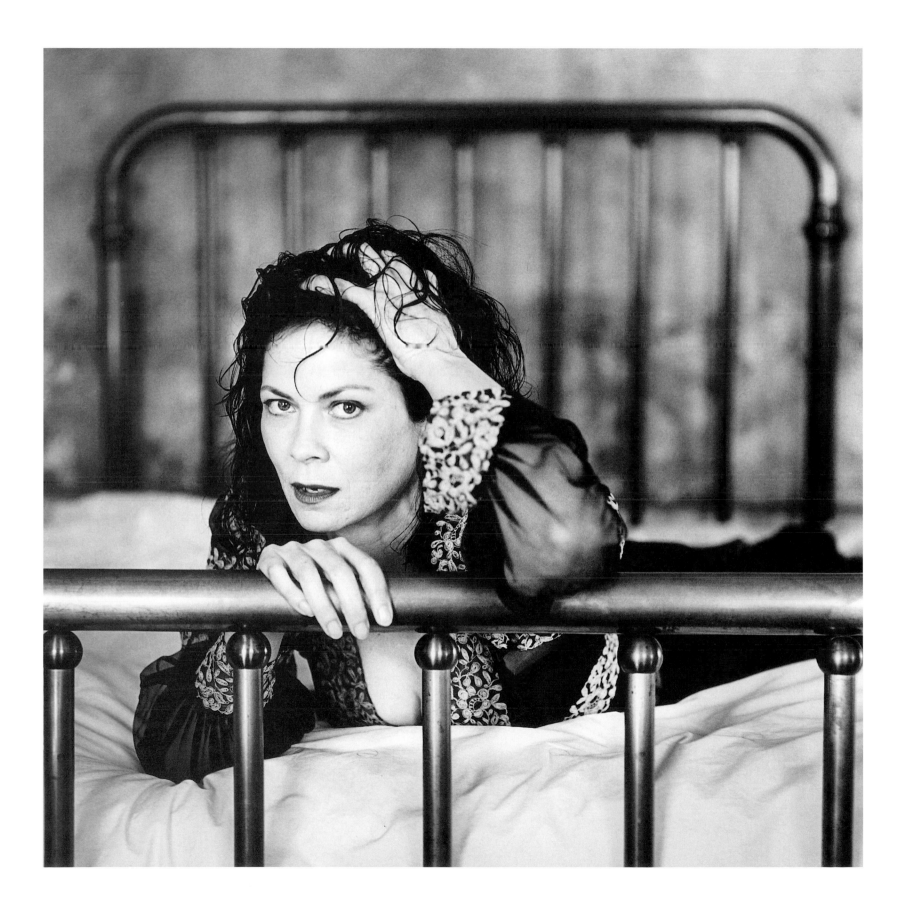

Born: 5/4/50

After a certain age, women seem to become "invisible" in our culture. It happens in subtle little ways:

guys stop whistling, eyes don't linger when you're introduced, you aren't helped as quickly and eagerly in a service situation.

You go from being the center of attention to being marginalized.

This lack of recognition and engagement was disconcerting to me at first. I felt like I was about to be erased as an "old broad" and so

I fought back. I began to move through the world in a different way, to step into my skin a little more and say, "I'm here!"

Society makes women want to deny the fact that they're aging. We're under pressure to twist ourselves into an image of beauty and

perfection that's always been unrealistic, unnatural, and unattainable. It's sad to see a woman who tries to look younger than she is by

dressing like a teenager. Wearing clothes that look good on your body now, the way it really is, can be very sexy.

As an actress, I find that most movie roles don't reflect the full range of womanhood—we're often

just a sidekick, a mom, appendages, or ornaments who are too demure or too hysterical. I think it's important that we have

more images of real women and scenes that portray the deeper complexities of mature relationships.

I recently had the opportunity to play the role of a middle-aged waitress having a flirtation with a middle-aged man.

I was able to bring the character closer to my true self and chose to keep my hair gray instead of dying it. There was a sweet warmth

about these two ordinary-type people feeling sexy and having a genuinely great time together. You don't often see that

in the movies—usually the male lead is panting after a younger woman or, if he's flirting with a woman his own age,

it's often in a condescending, harmless, sexless manner.

I've changed physically but I find these changes to be healthy and natural, not limitations.

When you reach middle age it's a beautiful thing that happens to the face, to the body, and—more important—to the soul.

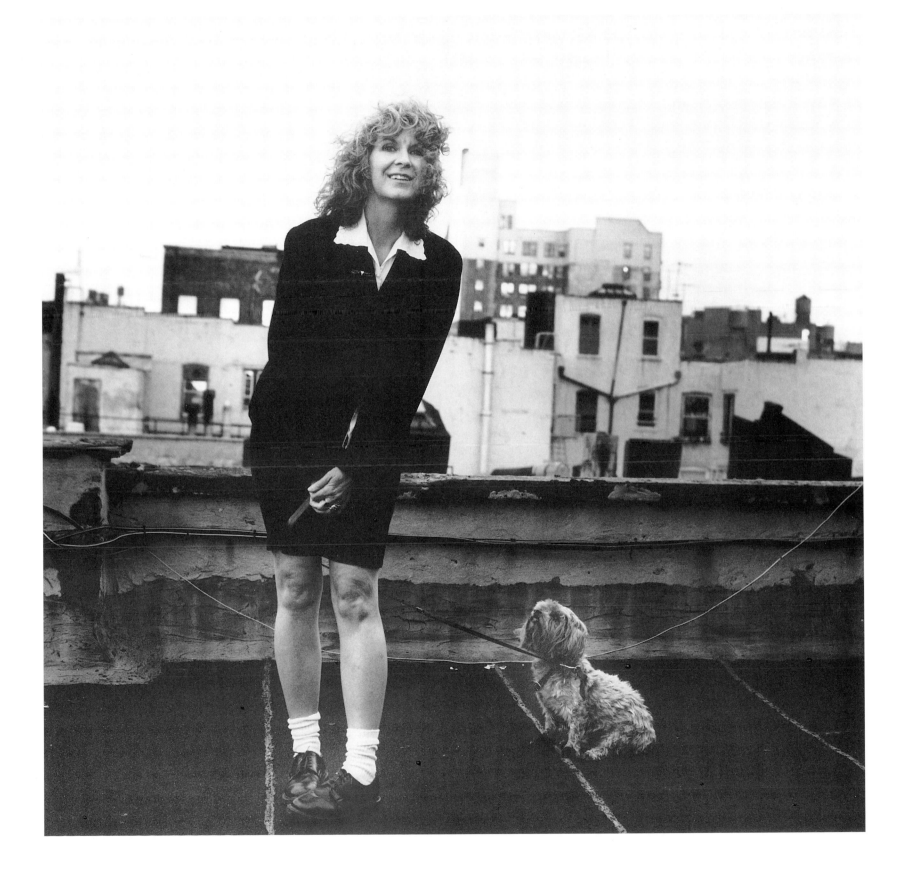

SUSAN GOLDSMITH WOOLDRIDGE

BORN: 1/30/46

Miracles happen. Magic develops from the inside out.

I believe we are creative forces in a creative universe. Each one of us is responsible
for what happens in our own lives—that's why I always make an effort to be joyful. I believe we can all tap into our inner knowledge
and create the world we wish to live in. By acting "as if" it will become—imagination works that way.

I had an extreme emotional breakdown when I was twenty, which taught me a great deal.
It was a surprise to discover the universe didn't fall apart when I did—spring still came when I wasn't holding the world up!

Through my breakdown, I learned I could not trust my rational mind—I had to trust information that comes from somewhere else,
from what is often called "intuition." I realized all that matters in life is to be balanced, sane, and whole, physically, mentally, and
spiritually. That's when I began to tap into poems and listen to things in the world speak.

Poetry has been seen as sacred, holy ground that only a chosen few can enter. But I don't buy into authority and I don't like
high horses or pomposity. I believe everyone has a *poet place* inside him or her. It's in our nature to
desire *controlled abandon*—that's how we find our genius, our visionary selves.

I love being in the position of teaching people how to discover the poetry within them and seeing the freedom it brings.
I want to create juxtapositions in poems, in language, and in life, to help myself and others take our minds and hearts to new places
and stretch the limits of who we see ourselves to be.

Poetry is about listening and catching things and writing them down. Poetry and sloppiness go together—poems slip in between the spaces.
Where I end and where I begin, the boundaries of who I see myself to be, disappear when I'm writing poems.

Dreams *can* manifest. Other people may envy them, try to knock them, or weaken your will, so it's best to keep your wildest dreams to
yourself. I've flown and leapt in my dreams—with my book, *poemcrazy,* and the classes I teach, it's all coming true. How marvelous.

Take a risk and dare to go for it! See what happens!

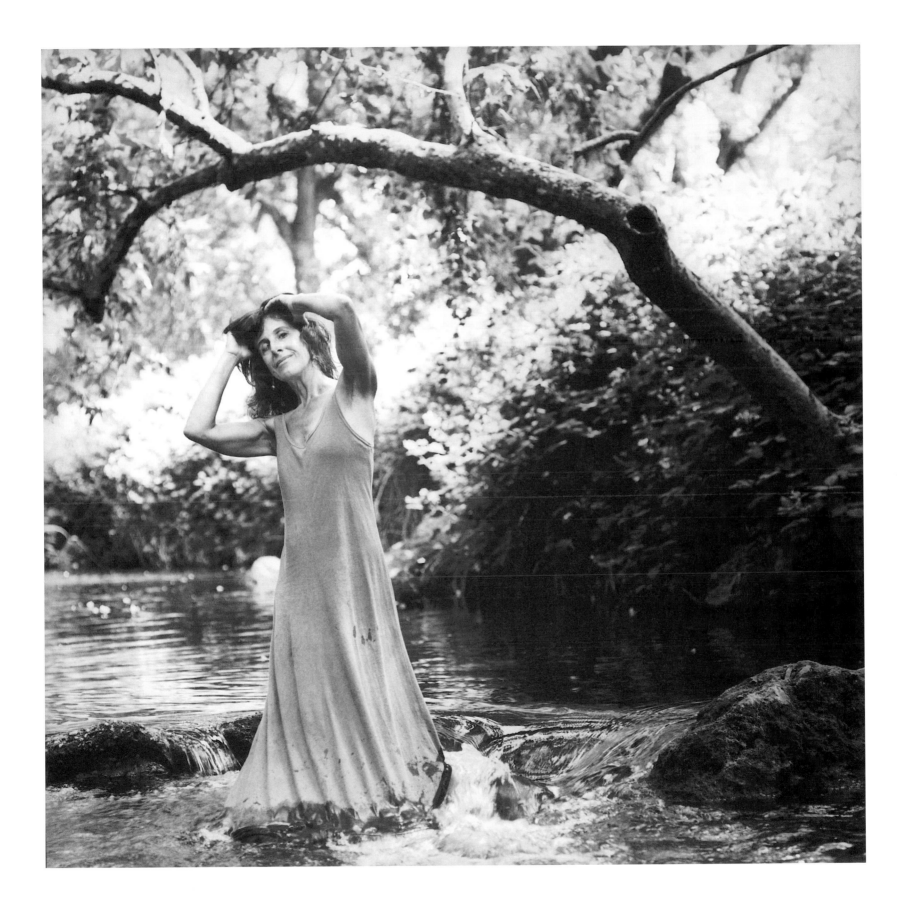

PRISCILLA LAWRENCE

BORN: 4/8/48

I care so deeply and so passionately about things in this world. I've never been able to hide my feelings—I'm a person who wears her emotions out in the open. Being emotional means that I sometimes experience deep pain, but it also lets me experience great joy, too.

I find the most powerful thing I have to give is love.

Love is transformational—it inspires, comforts, and nurtures every aspect of our being.

The children in my classroom know how much I truly care about them. You can't fool a five-year-old about your intentions!

Teaching combines the two things that mean the most to me: psychology and working with kids. The children deserve my very best.

I know I have a positive affect on their young minds and that brings me a great deal of satisfaction.

When I was young, I didn't like being a girl; I thought boys got to have all the fun. I had two brothers and there were no other girls in our neighborhood. I ended up playing by myself most of the time—it was my first taste of sexual discrimination.

I began to feel wonderful about being a woman when I went to college and developed close friendships with female classmates.

I discovered the strength and beauty of women and saw how much we have to offer.

At the end of my thirties and the beginning of my forties, I really started coming into my own.

I realized I was a better mom and a better wife when I started caring about *myself*. I became more of a person that I liked.

I've been a dedicated runner for twenty-five years. When I run I release my emotions and just let everything go.

It's the time when I feel the most safe and free.

I'm a lifelong learner who's still growing. Once my children are settled into their own lives, I'll go back to school. Learning keeps you alive inside. I have an adventurous streak and am looking forward to the next phase of my life. I'll never be at a standstill.

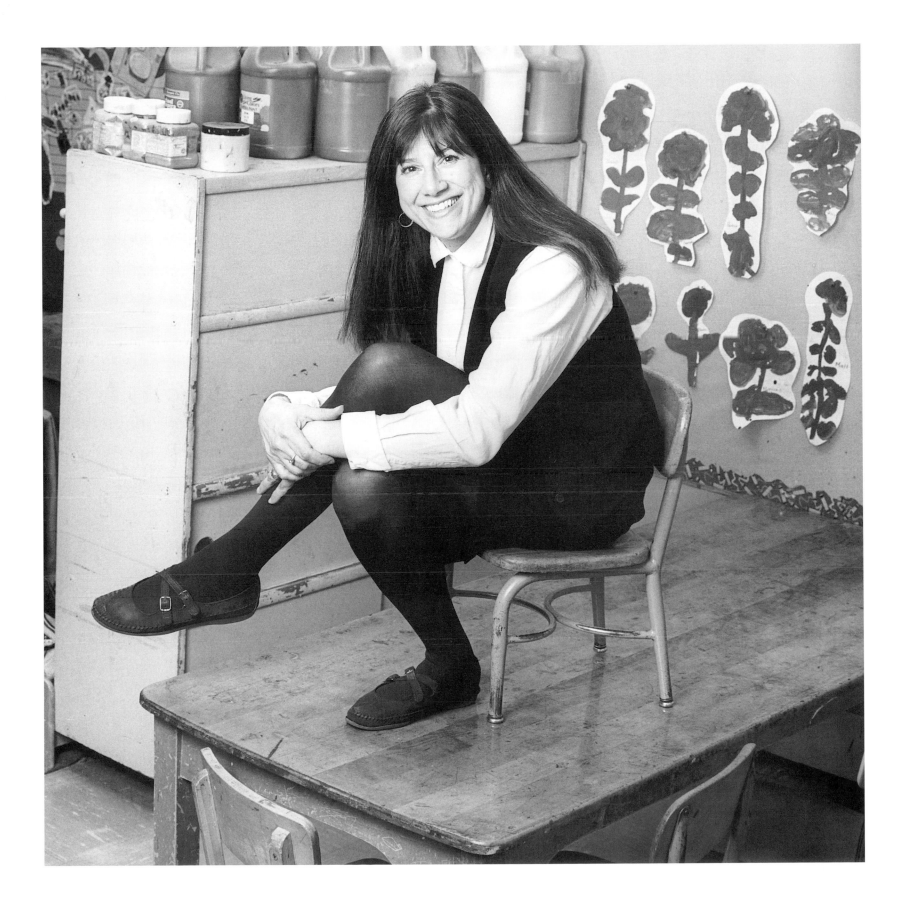

MARY BEATRICE WILLIAMS

BORN: 3/26/47

My magic number has always been fifty. Even when I was a teenager, I couldn't wait for my fiftieth birthday.

Now that I'm here, I've never looked so good and never felt better about myself and who I am. I don't try to make myself look younger.

I see wrinkles and think, "YES! I'm getting older!"

I got married at sixteen and had five children by the time I was twenty-five. Being married made me feel like I was, suddenly, a grown woman. It used to frustrate me when salesmen came to the door and asked if my mommy was home; now people can't believe it when I tell them I'm a grandmother. It took me a while to look like a mom, so I guess it'll take a while for me to finally look like a grandma.

I have a deep line across my forehead. I call it my "lifeline" because it reminds me of everything I've gone through and gotten to the other side of. It's where all my troubles have ended. I like it; I've earned it; I deserve it!

I am proud to be a black woman.

I know who I am, where I come from, and all the ingredients that make me. It took all my ancestors to make Mary Williams.

I love that—I know they're still there, guiding me.

We're all pretty much alike. Regardless of our race, 75 percent of our genetics are the same. It's a shame when someone concentrates on the 25 percent of our differences rather than on what we have in common.

I lecture on multiculturalism and diversity. Whenever I see inequities I will speak up. I carry these issues close to my heart.

I think life is damn good because I'm here—still!

I have so many different women inside me—from the pious person who talks to God to a woman who wants to kick ass. I run the gamut.

I live my life to the fullest and I'm still growing—God's not through with me yet!

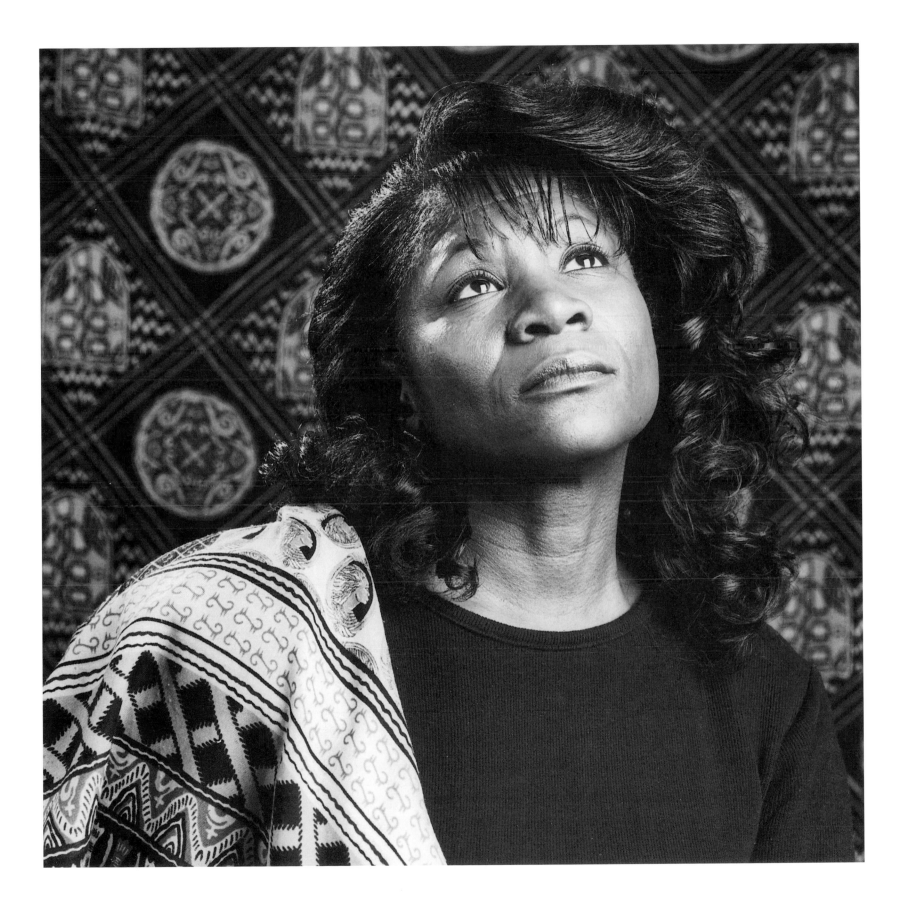

In my twenties I anticipated what it would be like to be thirty.

In my thirties I anticipated what it would be like to be forty.

Now that I'm forty, I don't care anymore. I try to think of aging as a spiral, not as linear. There is no beginning or end—there just *is*.

I realize that I'm on a journey, wherever it takes me, and I want to be involved in each step. I am much more comfortable with who I am now and am no longer driven by conditioning. All those years of wishing I was someone else helped me get sick of wishing. Now I concentrate on working with what I have and appreciating my unique talents and abilities.

Men don't get crucified for aging. But women are made to think they shouldn't show their age—or even admit it, for that matter. In our culture, we're bombarded with images of women who are mostly under forty and airbrushed. It's a problem for older women who think they have to have a certain, unattainable look, and then they flip out because in reality it's only an illusion.

Music is a way for me to express my emotions and feelings—it's a language I'd be lost without. I'm always inventing melodies, singing in my head or humming to myself. When I compose it's a matter of liking the sound I'm feeling. Many images are elicited from that sound, which then become the song lyrics.

Music and rhythm aren't just what we categorize as rock, jazz, blues, or whatever. They're there, all the time, in everything and inside of us. It's our birthright. There's a rhythm in the way the moon pulls the tides, in the way we walk, in the way someone gives a hug, even in the way we drive a car. If we weren't in sync with rhythm, we'd have a lot more car accidents!

Some people express themselves through math or language or color. These are all beautiful things, all instruments of expression. For me, music is transcendent, and elicits deep feelings and emotions. Sounds and rhythms are everywhere—they are the cues to everyday life. I get the biggest high out of them!

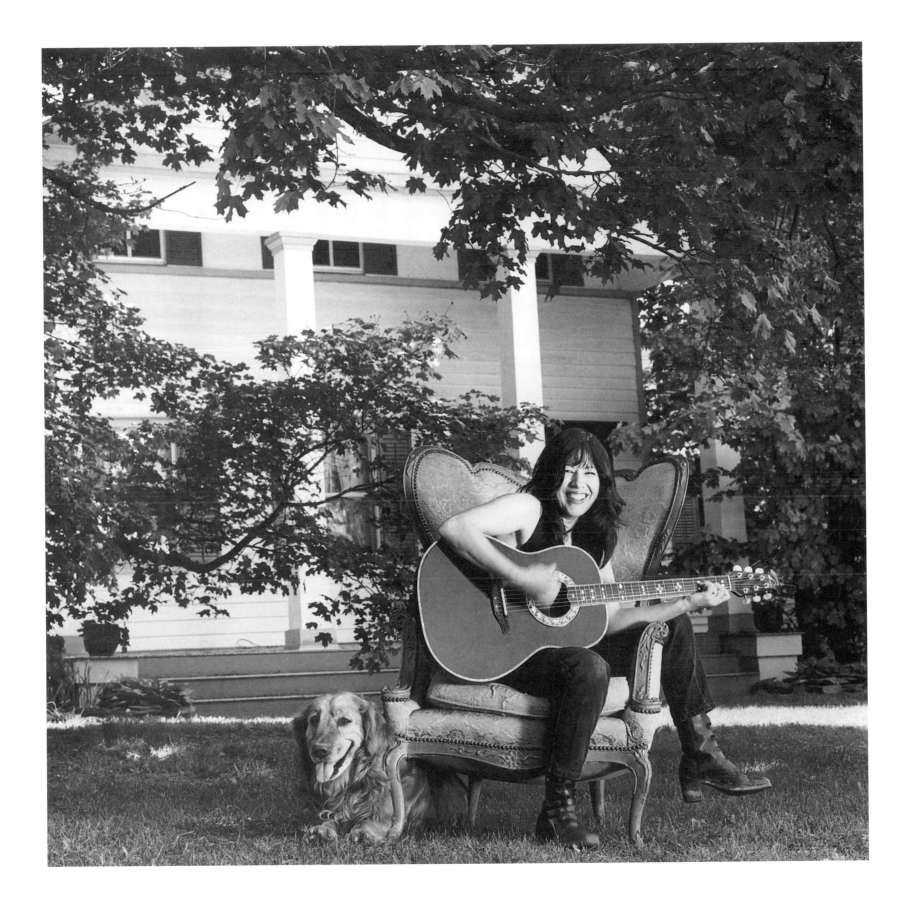

DONNA MARIE PITANIELLO

BORN: 3/30/45

It's easy to look good when you're young. You become a different force to be reckoned with as you age. There's a wonderful quality of awareness and depth that is difficult to achieve unless you've lived a while.

It's important that everyone in the media is not twenty-one. I love modeling and being a visible role model to other women. Paper dolls—attractive women who are flimsy of spirit—annoy me. I feel strongly that mature women have so much value and the world's view of us is not positive enough. I refuse to have them dismiss us. Living well will be our best revenge!

People get a kick out of the fact that I tell my age.
They're often shocked because I've always told the truth. I really don't mind aging—I feel better than ever because I've become comfortable with myself. It's amazing the things you discover inside yourself through the process of maturing.

As women, it's important that we learn to respect ourselves. We can't expect anyone to save us from ourselves or the world. Admiration isn't bad. The reflection of love, how someone else sees us, is nice. But I learned a long time ago not to trade on that. We must always depend on our own inner mirror to reflect our true image.

For me, any worthwhile journey begins inside.
I've taken the time to ground myself, find my own inner voice, and start trusting myself. It took a while but I've finally discovered life on my own terms. I've encouraged myself to explore my talents, limits, needs, and desires, to set boundaries and give myself—without giving myself away.

The most important thing for me is to replenish myself with quiet time—it gives me that much more to share. It's taught me to value my spirit, what's inside me. I've discovered how wonderfully liberating it is to let myself have dimensions and give myself permission to really *be*.

Life doesn't have to be serious all the time. Who knows how long we've got? I enjoy being in the moment and am having the best time of my life. I've never been so lighthearted—I feel like a kid again.

I want to live with wit, wisdom, courage, depth, spirit, and honesty. A splash of elegance is nice also!

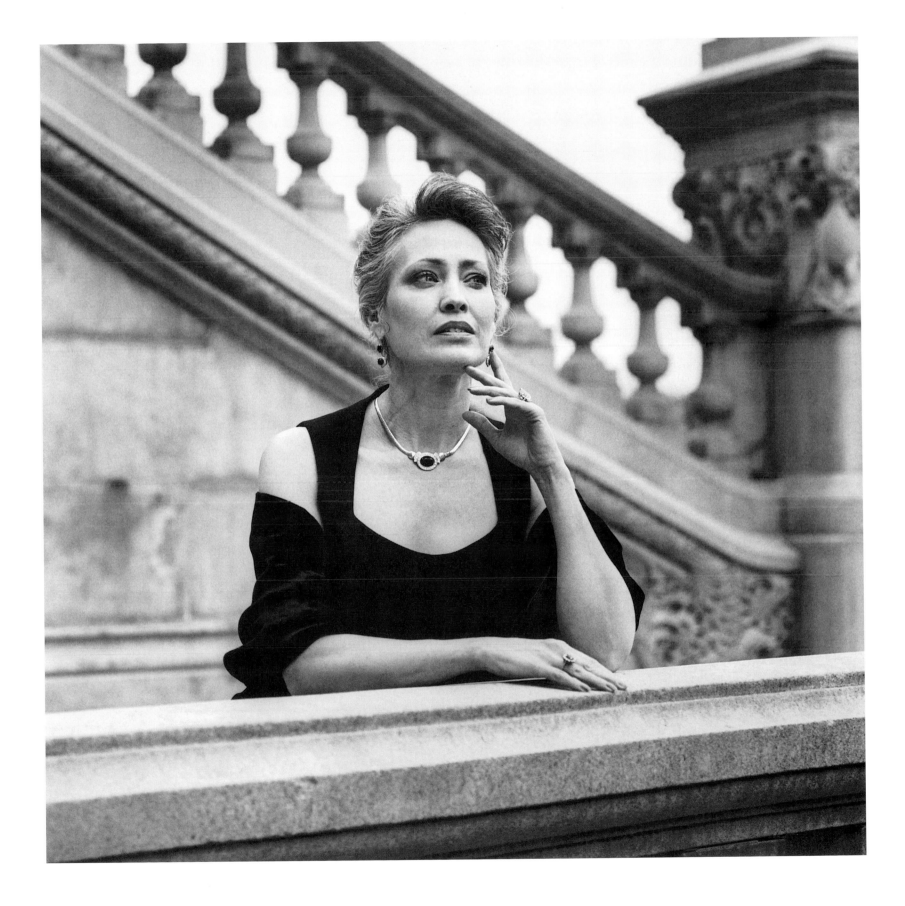

BORN: 9/10/53

I know if anyone ever tries to rape me—even if they succeed—I'll have their eyes, their ears, and will bite their nose off!

The work I do teaching women self defense is important to me. At the beginning of class, I ask the students if they are capable of

scratching a rapist's eyes out. Most of them are shocked and horrified at the idea. I make them understand their bodies are sacred and

that no one has the right to take anything from them. They come in feeling weak and leave feeling strong and confident.

If just one woman is helped out of one situation at one time in her life, through what I have taught her,

that's the greatest reward I could ever hope for.

Martial arts is a male-dominated society. I was told a woman would not succeed. But I beat the odds and proved them wrong!

Now that I'm a sensei (teacher), I don't brutalize my male students to make them fear me and gain their respect. I would rather earn

respect for my talents and abilities. They are a gift that I can share with others.

When I started studying karate in my twenties, I would go home with black lips and bruises all over.

But I kept going back because deep inside I knew it would be my vocation.

I have a strong mind and a healthy body and know I can do whatever I want to do. I appreciate all the gifts God has given me.

I feel secure, I know where my direction is, and I'm confident that I am capable of becoming even more successful.

Success comes with what I give, not what I take in this life. By giving I receive in so many ways.

I'm the best I've ever been and will remain at my peak for years to come. That's not to say I wasn't afraid of turning forty.

When I was thirty-nine I made a conscious choice not to lie about my age—instead I decided to say, "Look at me, I'm forty!"

I walked into class and announced it was my birthday. In celebration we performed every movement and technique forty times.

It was truly a joyful day.

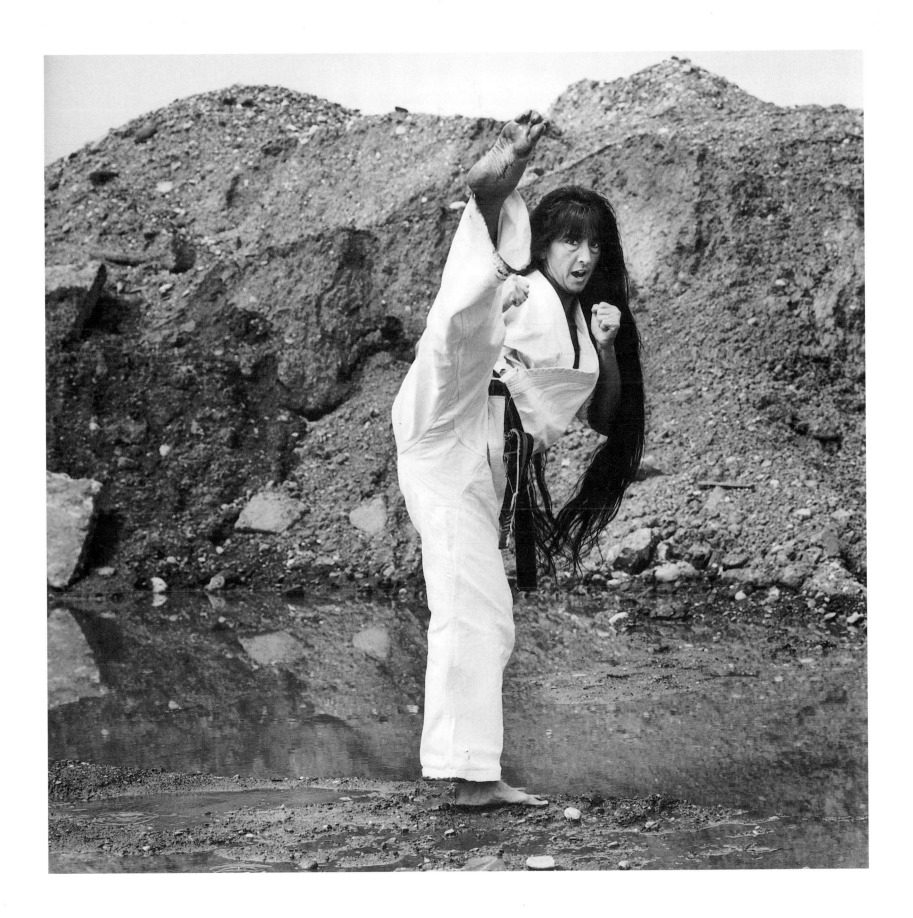

Aging is greatly affected by our ideas, and we get such conflicting messages from society. Is it about how we look? The new lines and changes in our faces? Is it about acquiring wisdom? Is it learning to listen to our inner voice?

It's become increasingly important for me to harmonize with the soft, whispering voice inside that guides me. When you connect to your inner self and the loving energy of the universe, you can hear your dream calling to you and then go forward to make it happen.

Women have sensitive, powerful, feminine forces.

We are intuitive by nature, connected to the quiet guiding light of the moon and the Earth Mother.

Women have this secret Mona Lisa thing going on when they get in touch with their inner sexual essence.

Through self-awareness and experience, we learn how to give and receive pleasure more deeply and with less inhibition.

It makes our capacity for intimacy much greater as we age.

I believe in doing whatever it takes to stay unbroken. It's not easy to rebound from sadness or difficulty.

You need to gather your forces and go forward to regenerate your spirit. Anger, inflexibility, bitterness, and lack of compassion make people age. I've had hardships, and I'm not saying they haven't affected me, but I've focused on staying open to life. I've been a single mother for a long time and am grateful that my daughters embrace the erratic life and eccentricities that come with being an actor.

Some people think I'm naive, but I'm not going to change the way I am. I don't mind being told I have the heart of a child.

I love spending time in that place inside me that's serene and quiet. I've meditated for twenty years and it has been my source of inner peace. It helps me to not get caught up in the inconsequential, to ride life's waves a little better.

I live by seeking the truth within and staying forever open to love.

Cherish yourself. Stay soft and lovely. Always follow your heart.

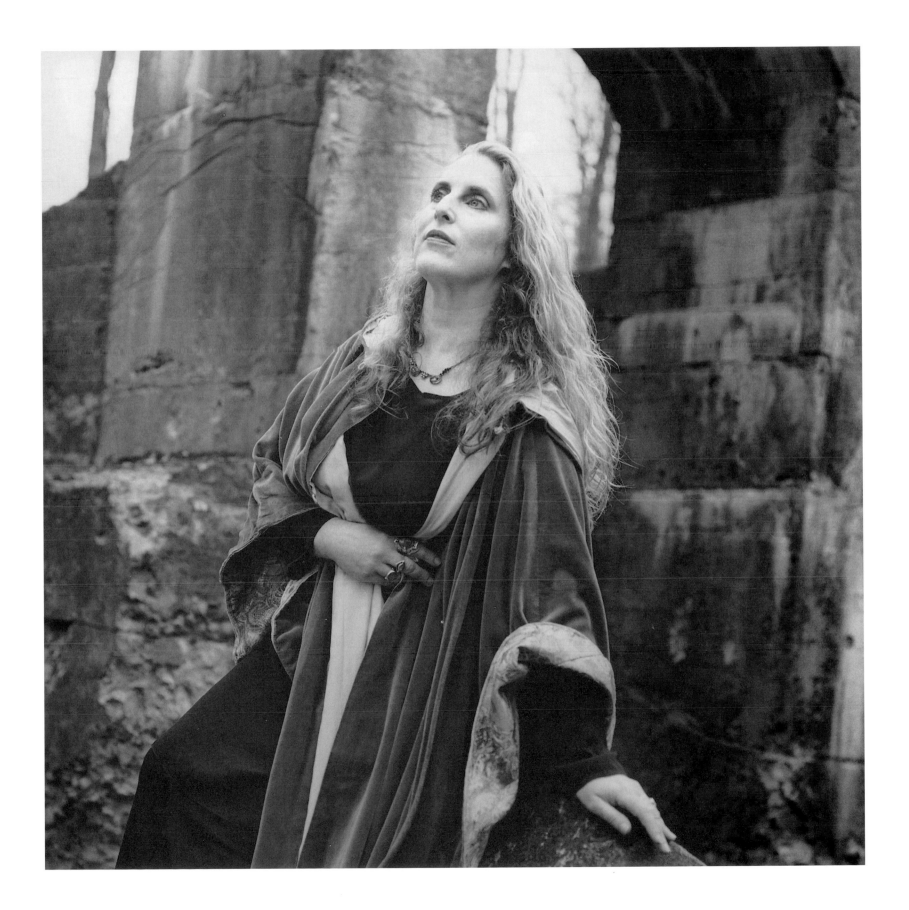

ELIZABETH GRAHAM

BORN: 12/29/55

What is growing up, anyway? Up to what?! I don't want to grow up to meet other's expectations, just my own.

I really do love getting older. I mourn for people who are troubled about aging.
Some women are brainwashed into believing that wrinkles are not cool.

The wrinkles on our face become the life we live. We earn the face that we wear. You are whatever you exude—it's what you believe about yourself that comes across. So many people with features one would not describe as conventionally beautiful become incredibly attractive if they have the right attitude.

Aging gracefully is really about loving yourself enough to take care of yourself.
If you maintain a straight and proper alignment, walk tall with a spirited gait and positive attitude, you'll have a youthful energy.

I discovered that being a "square peg" is one of my finest assets.
I've always seen the world differently than most other people and I'm grateful for that. I've found that if I want a satisfying quality of life and way of living, I have to find my own inner and outer balance. It's within me and no one else.

Sexuality is wonderful, but feminine wiles should be used discriminatingly—there's a time and place to be sexy, sensual, alluring, and evocative. What I love is how women can be sexy while being androgynous. Sometimes less is definitely more!

Guilt is a useless emotion. I always try my best, so if someone wants to make me feel guilty, I just say, "OK, I made a mistake. So crucify me." Mistakes don't make us bad people—we're *meant* to make mistakes. They're a part of learning.

This is the beginning of the second part of my life. I have more energy than I've ever had and feel far more focused. I know that what I really want is to be happy—it's as simple as that. It's time to hang on tightly, fasten my safety belt, plunge in, and have fun.

I'm not giving up. I'm not settling. I say age gracefully and take it in stride—we're *all* aging, dear.

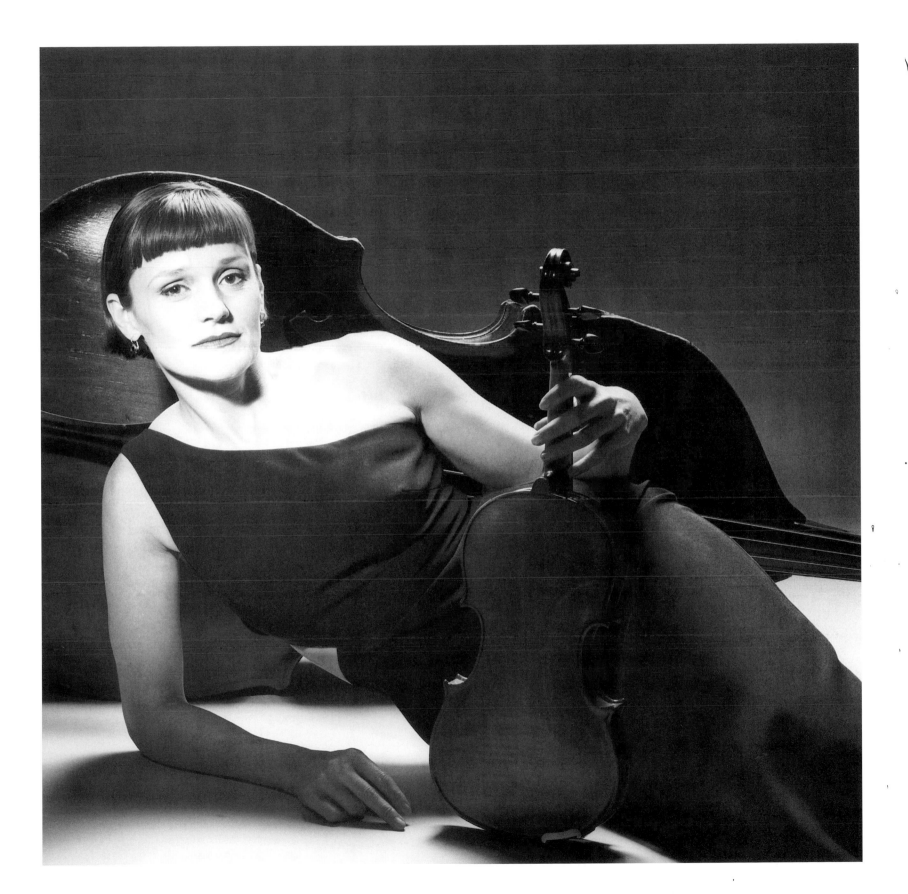

BORN: 4/24/43

When I was young, I had a numinous vision of White Buffalo Woman, an ancient mystical teacher who stands as a central figure

in the spiritual traditions of many native tribes. In my vision, I was reminded that the true power of women is to nurture and renew life,

although these values are not held high today. It is our charge to uphold that feminine power and live in active harmony with the full

Circle of Life. We have an incredible challenge ahead of us to rebalance our culture by focusing on the sustainable life of the whole.

Yet, first we must balance and sustain ourselves by loving and taking care of ourselves.

The way to give your finest offering back to life is by becoming the essential self you were created to be.

Therefore, it's important to slow down, get quiet, and release anything that gets in the way of being your fullest, truest self.

It is clear to me that health and vitality can go with us into our older years.

Recently I felt heavy and worn out, like age was getting me down. Now I'm back to the willowiness of youth, my essential self,

because I had the courage to leave my remunerative work and go on retreat—to nourish myself with natural nutrients, outdoor exercise,

fasting, clear air, and a program to clear trauma and fear from my consciousness. Nourishing the vital life force brings both health and

spiritual awakening: it echoes from the body to the mind, which becomes clear, so that consciousness becomes open and flowing.

Once you shift into the contemplative side, magic is afoot.

I choose to give authority to magic, Love, and infinite grace in all realms of my life.

I am my own experiment. I try things out on myself and then share what I find with others in the hope that

the experiences that have transformed my life may help empower others.

My focus has always been on what works for *all* human beings—the ancient truths that flow across all cultures to embrace global humani-

ty. Following their wisdom, we can move into a new era of harmony, beauty, and abundance.

I am a singer of a new song of the golden dream which is slowly becoming real on Mother Earth. My work is to awaken that dream,

give voice to it, and bring awareness to others so that they, too, can harmonize with its rich truth.

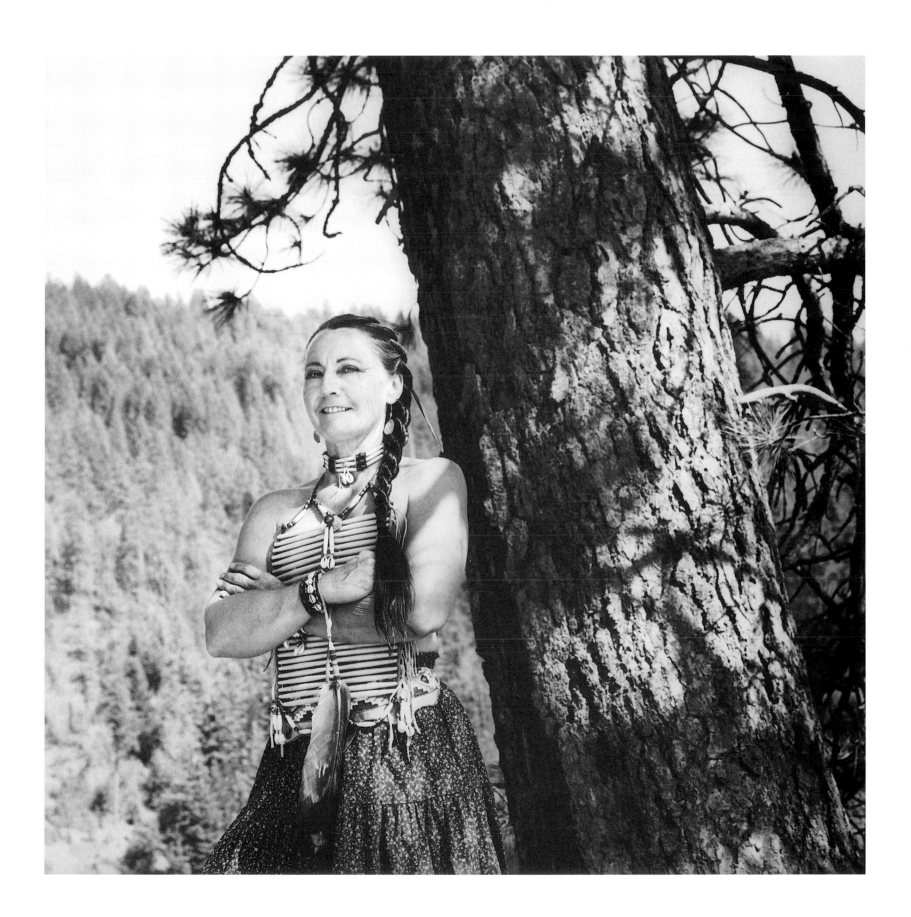

SUSAN PEERLESS

BORN: 4/22/47

Life is about the choice between three kinds of power:

the power of money, the power of position, and the power of authenticity.

The first two can be given to you or taken away—the only satisfying allegiance is to the power of the person that you are.

I've worked full-time my whole life—I've never not worked.

I've been the executive director of a trade association for the past eighteen years, and prior to that I was involved with

legislative work. Of necessity I had to understand that I'm a whole, not parts that can be ripped apart by guilt.

If you're at work and your child has to go to the hospital, of course you leave the office.

If you're at home and a major issue comes up with work, you get a baby-sitter and do what you have to do.

There are lots of outside influences that try to set standards that are not necessarily valid for an individual.

For me, life has never broken down into jobs and tasks; it just flows naturally. I'm not a different person at work or at home.

The challenge in life is to just be a person.

Aging has brought with it the power of discernment—the ability to know where true joy lies and the recognition of my own lovingness.

And the process of aging becomes exponentially more joyful when I deepen my sense of self.

I can see the difference between a woman who is experiencing joyful aging and one who is not.

The joyful woman emanates a natural, radiant beauty that's not dependent on age, physical appearance, or status in society.

There is a lightness about her—she doesn't carry her age around like a heavy load.

As I've gotten older, I've gotten better at caring for myself and others in my life.

My relationships have a more spiritual element, and I've become a better mother, a better friend, and a better colleague.

I feel more like a woman, in balance, with each passing day.

LINDA GREENWALD

BORN: 5/11/51

I learned in my twenties that being a grown-up had nothing to do with my earlier vision of it. There were the highs of independence,

but I wasn't prepared for the all-out responsibility of having no one to answer to but myself.

My childhood concept of what it meant to be an adult finally took hold when I reached my thirties—I had a husband, three children,

and a nice home. But I got lost ministering to my family, and knew, somewhere inside, that a part of me wasn't being tapped.

It was like a dam burst on my fortieth birthday. Within six months, my mother died and I decided to get a divorce.

That's when I began to find my inner self and experience the joys and pains of a new beginning. It took incredible strength and

many falls, but it was a satisfying battle because I felt good about what was at stake—me!

As long as I don't hurt myself or anyone else, I believe in taking things to the very highest-pitched, intense depth. The state I'm in today—

raising my kids, jogging every day, and playing the piano like never before—has been a big, wonderful surprise. My confidence has grown,

and I don't think anyone or anything could ever jar me again. It's great to know that if you believe your time is coming, it will.

I started running during my divorce to help me stay focused and centered—it was like my spirit needed to get moving.

I love having my body feel strong and conditioned, and I'm addicted to fresh air.

Before I wind down I want to take my running to the hilt, so I'm training to run in the New York marathon this year.

It's twenty-six miles, more than I've ever done. I can't wait—I know it will be the biggest high.

Now that I'm forty-six I'm starting to think about what I want in my fifties.

At forty I had to prove I was 100 percent sexual, 100 percent jock, and 100 percent mother.

I've done that, so now I want to move into a different, less intense mode—maybe I'll gain a few pounds and relax a little.

BORN: 10/5/51

Being a woman is a precious birthright. I believe women strongly feel the essence of transformation and change

and can direct that energy into their lives when they reach their forties.

I have many older women friends, and I recognize them as great mentors. They are amazingly wise, and I love their zesty, sexy,

iconoclastic ways. They've demonstrated that as women age, we can continue to become more extraordinary, inventive, and creative.

We are sacred, spiritual, and sexual beings every moment of our lives. When we're younger, we are more attuned to sensation and novelty,

to the excitement of the new. I believe the richest, deepest, holiest sex occurs as we age and grow to understand ourselves better. We can

connect deeper as the divine in ourselves meets the divine within another. Imagine tales of seduction in our eighties and nineties!

Sexuality and sensuality are polymorphous, poly-physical, in everything we want them to be.

Whether instinctual or learned, women have the ability to stretch the limits of sensual pleasures into different moments of life.

We can experience it in music, in massage, in nature; we can appreciate another beautiful woman without it turning sexual.

A great moment of shared sensuality for me happened at dinner with a group of women friends.

We were eating fruit, wrapping our tongues around it, feeling the texture in our mouth, letting the juices run down our cheeks.

We were laughing outrageously and having a great time. For men, this experience would be totally sexualized.

Men and women have distinct ways of being in the world—and I love the differences!

I co-own a bookstore and community center with my husband. It's a dignified profession to transmit knowledge and new ideas—books

have the ability to transform and I am passionate about them. Working together has never been a problem for us. We share power easily,

laugh a lot, and enjoy each other's company. Our vision is to expand into a new store in 1999 and become a major cultural center.

I've never felt sexier than I do now, in my mid-forties. I know how to love my body as it is—full, round, and curvy.

Being a woman is a great, beautiful, wonderful gift to the world!

BORN: 7/13/56

The loss of my mother when I was eighteen forced me suddenly into the full responsibilities of adulthood.

It was the catalyst for me readily taking on the "perfect wife" role.

I was young when I got married and had never experienced single life out on my own.

Even though I had a career, I still maintained the 1950s June Cleaver mode of running the perfect household.

It was all new to me and fun at the time, but not very realistic. I put way too much pressure on myself.

Now that I'm in my forties, I've thrown the idea of the perfect wife out the window.

I don't live just to please others anymore. I'm much more independent, self-fulfilled, and self-sufficient. I know myself better and

accept myself more. I realize that being the perfect wife and mother really means just being happy with *myself*.

So what if there are dirty dishes in the sink? My husband and the kids will pitch in; we're a team.

I love being a mom and feel blessed by my two beautiful daughters.

Children don't belong to you—they're given to you to watch, protect, and help grow into the person they're destined to become.

I cherish every phase, even though I'm not the cool mom I thought I'd be! Much to my chagrin, I hear my mother's words

coming out of my mouth—from "Because *I* said so" to "You're not wearing *that* to school!"

I expected to be much hipper and more understanding.

I've gotten very introspective in the last couple of years. I used to think things were black and white, right and wrong. I now see that

things are more fluid, that everyone is different and every situation is unique. I'm much less judgmental of others—and myself.

I absolutely love being a woman—having the freedom of choice to do and be whatever I want—motherhood, intimacy with my husband,

close camaraderie with my sister and my friends, plus all the fun feminine trappings. Womanhood is having your cake and eating it, too!

If there is reincarnation, I definitely want to come back as a woman again.

Born: 2/4/42

My whole being finally feels like it's on the right road. For the first time in my life,

I can claim the original meaning of the word "virgin": owned by no one.

In ancient times, virginity was not a physical condition or sexual issue—it was a way of being. Virginity embodies the essence of

individuality, which says we have a self that merges in union but still maintains its independent state.

That is the wonderful paradox I teach women in my therapy practice: that it is possible to merge and still be autonomous.

Freedom does not come with age—nothing comes with age.

Wisdom is not a matter of just growing older; it's a matter of really becoming your authentic self. This takes time, effort, and experience.

A person's internal core contains his or her ethics.

When your core is solid, it makes it easier to decide what's right for you—and *that's* the *real* ticket to freedom.

The solid, central core inside me knows what I stand for and how I wish to use my energy. I don't move away from this self-knowledge.

The last time we know of a balanced union between the masculine and feminine energy was in ancient Crete.

For the past five thousand years we have been under a masculine value system which emphasizes hierarchy, dominance, and control.

Conversely, feminine energy connects us with nature and acknowledges that we're all one. By disavowing the sacred feminine, we have

destroyed our acquaintance with the sensual world and put our civilization at great risk.

Balance will only be achieved by the yin-yang union of both masculine and feminine energies.

To help bring feminine energy values alive, women should study their heritage and history, including what the feminine element

represented in past cultures. There is a great deal of empowerment in this knowledge.

Without the intuitive, we are left with only the rational. I strive to arouse feminine energy and teach life-enhancing values that

bring balance into our lives, influencing the way we connect and the way we love. As we move into a connection with

feminine energy, our senses open up. Humanity requires an open heart—and that requires courage.

R U B Y M O N T A N A

BORN: 10/5/47

I ain't no "black balloon" kinda gal about aging. I'm celebrating my fiftieth birthday with a party in Paris at the Eiffel Tower.

My life's been pretty joyful and I feel lucky I'm turning fifty. Fifty is nothing! I feel as young as I've ever been in terms of spirit dreams and the way I live my life. I fly fish, hike, and run my own business—and I still love jumping into my Volkswagen convertible and taking off whenever I want. As I've gotten older I realize I want to live to be one hundred!

Long-time friends are great. Every summer since the 1970s, I've had a reunion with thirty of my closest friends. We meet at this beautiful place in Montana where we ride horses, raft, hike, and dance like fairies in the woods. I don't see my friends becoming older—I see them as beautiful as they were at twenty and a whole lot happier because they've decided who they are.

I do not surround myself with "spirit crushers"—people who don't believe it's possible for you to live your dream. I believe we age when we get miserly about our emotions and stop sharing our spirit. I think deep down everybody has the ability to feel free enough to do what they really want to do—they just have to allow themselves to go for it.

The first experience that made me into a "dime-store cowboy" was getting dressed up in a cowgirl outfit and sitting on a pinto pony to have my photograph taken. This was high theater for a five-year-old! I've kept that part of me excited and alive my whole life.

With Ruby Montana's Pinto Pony, my retail store and mail-order business, I'm the lost and found society that finds new homes for great kitschy objects. It's part of my obsession for fun things and collectibles that have a lot of heart and are worth preserving.

I consider myself an outfitter to the cosmic cowpoke. Cosmic cowpokes have a "third eye" that sees more than your typical cowpoke. The spirit of the cowpoke rides within—it's someone who loves life and what they're doing. We know who we are, and there are many of us all over the country!

Yippee-io-kyaa!

BORN: 11/9/51

Being beautiful and weak won't cut it for me.

I teach high school students, and there are times when it is useful for me to be able to arm or thumb wrestle.

Eighteen-year-olds respect me for my strength—it makes a point.

After having a couple of babies, there were big changes in my body that I wanted to correct. I wanted to be strong physically because I wanted to be strong emotionally. Getting biceps was tantamount to getting tough. When I developed a strong upper body, I felt like I could deal with *anything*—from pulling someone out of a burning building to duking it out with a guy.

I feel great after a workout: healthy, alive, and alert. Teaching four fitness classes a week at a local YMCA, I surround myself with women who have the bodies and attitudes of people much younger than they are.

Age is for wisdom and being generative. I want to have the energy to give something back. In my twenties I was idealistic, enthusiastic, and confident, but I didn't really have a clear picture of who I was. My thirties seemed like the era I needed to "get through." I had wanted it all—now I had the unfathomable job of *maintaining* it all! I became good at juggling plates, somewhat frantically.

Now that I'm in my forties, life is as full as ever, but more balanced. I find contentment in being more reflective and choosing my commitments selectively. As I've simplified my life, I've learned that less truly is more.

When I was younger, there wasn't any real encouragement for a woman to develop her body other than to look nice in a sweater.

At forty, I have a much deeper appreciation of the connection between how I feel spiritually, emotionally, and physically.

I feel much more fit now than I did when I was thirty. I hope I'll be even more fit when I'm fifty.

We're in this frontier of womanhood where everything is possible. I don't want to be passé.

I want to be on the cutting edge of what it means to be a mature woman—strong, sexy, and vital.

A U R O R A S M I T H

BORN: 6/1/32

Since I was a child I've felt that women were somehow superior beings.

We're more complicated, better grounded, and, for the most part, gentler creatures.

Don't get me wrong—I think men are terrific and I love them dearly. But I would not choose to be a man—

I love being a woman.

Aging has been liberating because I have a much better sense of who I am and what's important to me.

I feel freer to speak my mind and express myself without worrying what other people think. I make choices based on

what feels right to me, and if someone judges me it really doesn't matter.

What I don't like about aging is the cellulite and crepey skin. It's not pleasant to watch your body dissipate, but that's a part of life.

If it bothers you, you can always run a few extra miles on the treadmill!

As I age, it's important to me to stay young in my mind. I was worried that when I got to be an old person I would get prissy and

stodgy—thank goodness I haven't! But I guess I've always had an avant-garde, bohemian streak. I don't think we change all that much as

we age—unless we want to. If you're uptight and rigid when you're young, you'll probably be uptight and rigid when you get older.

In my younger years, I felt like I needed tons of people around me to feel happy and fulfilled. Now I don't mind being alone one bit.

I especially like taking my dogs for long walks. If you want unconditional love, get a dog—they're the only ones who will give it to you.

I'm happy to be who I am where I am. My husband and I just retired and are living in a nineteenth-century house in the western hills

of the Berkshires. It's great having the leisure time to pursue painting and sculpture, to travel, and to study the piano.

My new love is a restored 1891 Steinway upright piano.

One of my goals is to play a Beethoven sonata well enough to please me.

I used to worry about pleasing other people—now I just want to please myself.

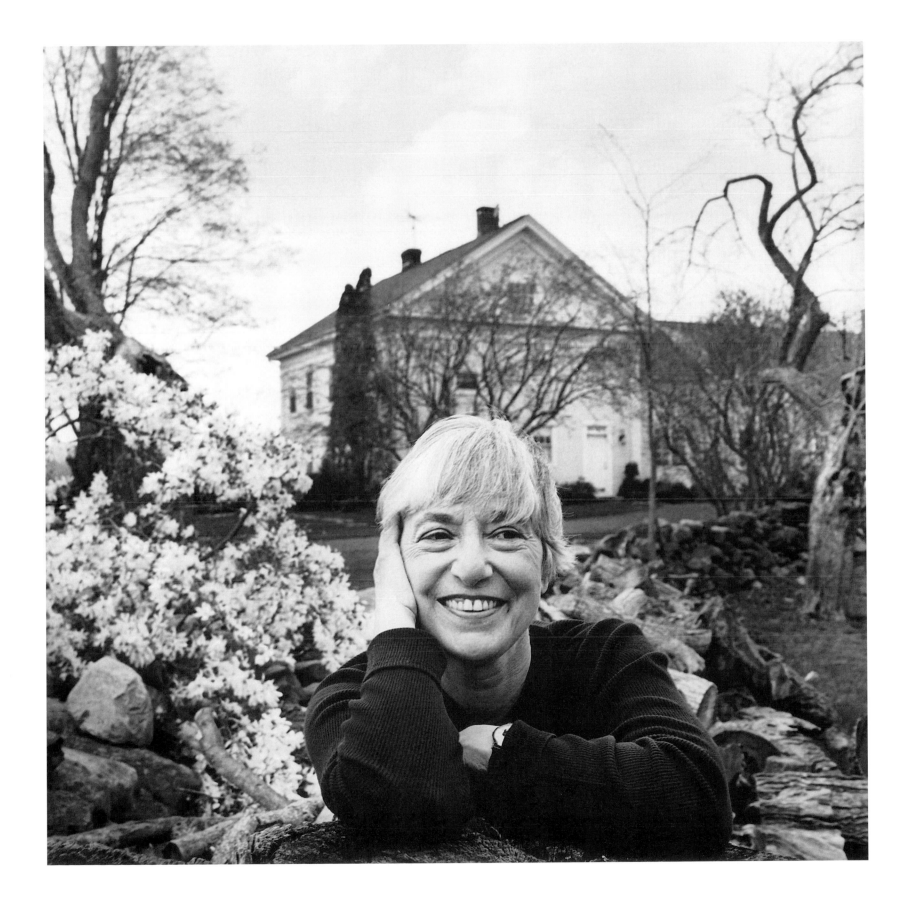

I used to think life had to be lived based on "shoulds" and "musts."

After spending many years doing what I thought I was *supposed* to do, I realized, "Wait a minute.

I did all the 'right' things with the 'right' people the 'right' way and it didn't make me happy. Now what?"

That's when I learned to let life unfold instead of forcing it. Now when I notice I'm feeling constrained I pay attention

because I know something is up; when I feel I have all the room in the world, I know I'm in the right place.

The key question I now ask myself is, "What will it take to live a fulfilled life?"

I have more questions than answers now—and it's a much freer, better place to be.

I spent six months after my fortieth birthday feeling totally depressed and wallowing around in misery.

It was somehow my mental line of demarcation—from then on there would be no more joy and no more fun.

Then it dawned on me I wasn't old—I didn't suddenly change and become decrepit, it wasn't the end of the universe,

and life did go on—the truth was I actually felt better than ever about myself!

I have been pursuing personal growth and digging around inside myself for the past few years.

When I made the effort to go inward I found my true essence and power.

I realized I had become friends with myself and was no longer trying to "fix" me—I wasn't broken!

On my forty-ninth birthday, I began to celebrate the beginning of my fiftieth year on earth and the second half of my life.

For a few months leading up to my fiftieth birthday I made it a point to get together with one or two friends at a time

to share our life stories. We became closer, our bonds grew stronger, and we created a real sense of community with one another.

It was a wonderful experience and a great gift to myself.

When I lay down on my death bed, I'll know that I didn't just go through the motions of living; I refuse to go that way!

I think it's pretty well guaranteed that I'll be a feisty little old lady.

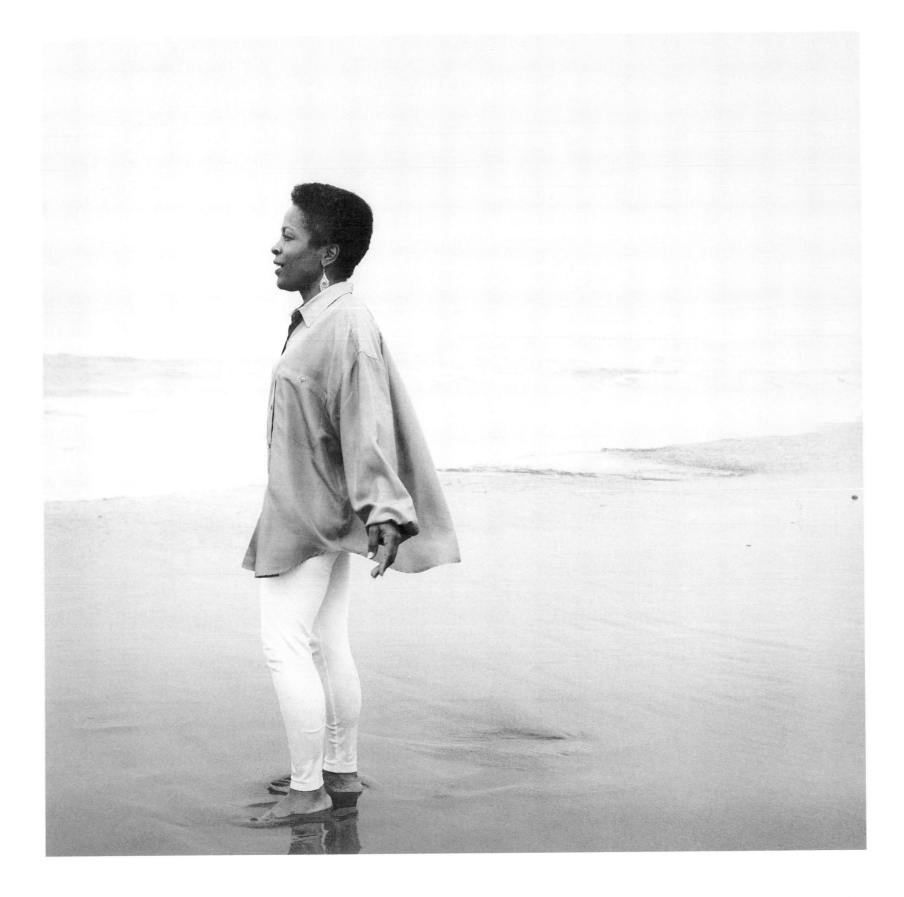

I always fantasized that on my fortieth birthday I'd being doing something exotically wonderful,

like sitting on a beach in St. Thomas.

I can't believe I got up to change a diaper instead. Who would have thought?

Look at me—I was twenty-five when I had my first child. Now, thirteen years later, I'm a new mother again.

What a blessing—baby Taylor is another little miracle. She's brought us so much joy.

I didn't plan to get pregnant, it just happened. When you're pregnant you just have this *feeling*. Somehow you just *know*.

I had just dropped my husband off at a job site when the familiar sensation came over me. I thought to myself, "No way!" But I

stopped at a shopping mall, bought a pregnancy test, and went into the rest room. Sure enough, it was positive!

I was in a high-risk category so they watched me closely during my pregnancy.

My doctor told me that half of his patients are forty or older and having their first child.

That's good because it means I won't be the oldest mom at the school when Taylor starts going to kindergarten.

My eldest daughter, Heather, is *thrilled* to have a little sister.

She wrote me a note when I was in the hospital giving birth that said, "This is the best Christmas present you ever gave me."

Until boys come on the scene or Taylor starts getting into Heather's nail polish, they'll be best buddies.

I'm usually a really fit person. I still have fifteen or twenty pounds I want to lose.

I'm going to do it—I just have to work a little bit harder to get it off this time.

I love being in good shape and I like to exercise.

Besides, with a little monkey and a teenager, I need the energy I get from working out!

Don't ever feel you're too old to have a child, they are definitely a blessing to be enjoyed, no matter what your age.

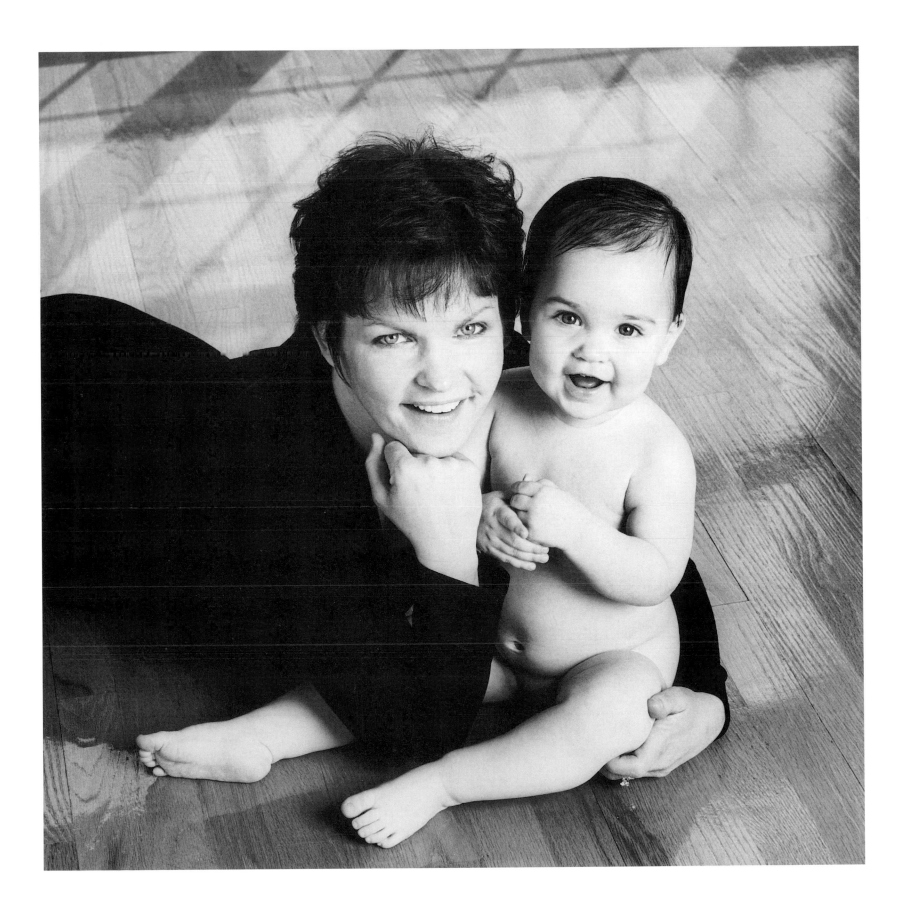

BORN: 11/19/46

I'm a fabulous fifty-one-year-old who has been to hell and has come back to live life.

Until I was forty I was an addict and an alcoholic—a horrible and destructive way to live. I ended up in a place where they shut you in a

room and lock the door. I pulled myself together and went to a rehabilitation clinic. It's been uphill ever since.

At rehab you have to turn yourself over to the idea that there is a higher power.

You draw on this higher power from within—the hard part is finding it. I try every morning to get in touch with it

and make an effort to stay in a good frame of mind by realizing how thankful I am for what I have.

I can't imagine life without men—I think they're great—but when it comes down to it, I think women are stronger.

This may be because women go through childbirth and the day-to-day nurturing of children. It's one thing to have blowhard bravado

and be able to act tough, but it's totally something else to be there for another person all the time.

Women seem to get stronger as they get older. I'm not sure if it's hormonal or if you just reach a point where you don't care

what others think of you anymore. It's great to feel free to speak up and say what's really on your mind.

I love what aging has done to my mind, but I could do with a few less wrinkles. And no matter how much I exercise there seem to be

a few extra pounds I just can't lose. Over the years I've gone from a size seven to a size fourteen—but it's a *strong* fourteen!

My life hasn't always been easy—but I wouldn't trade who I am or where I've been for anything.

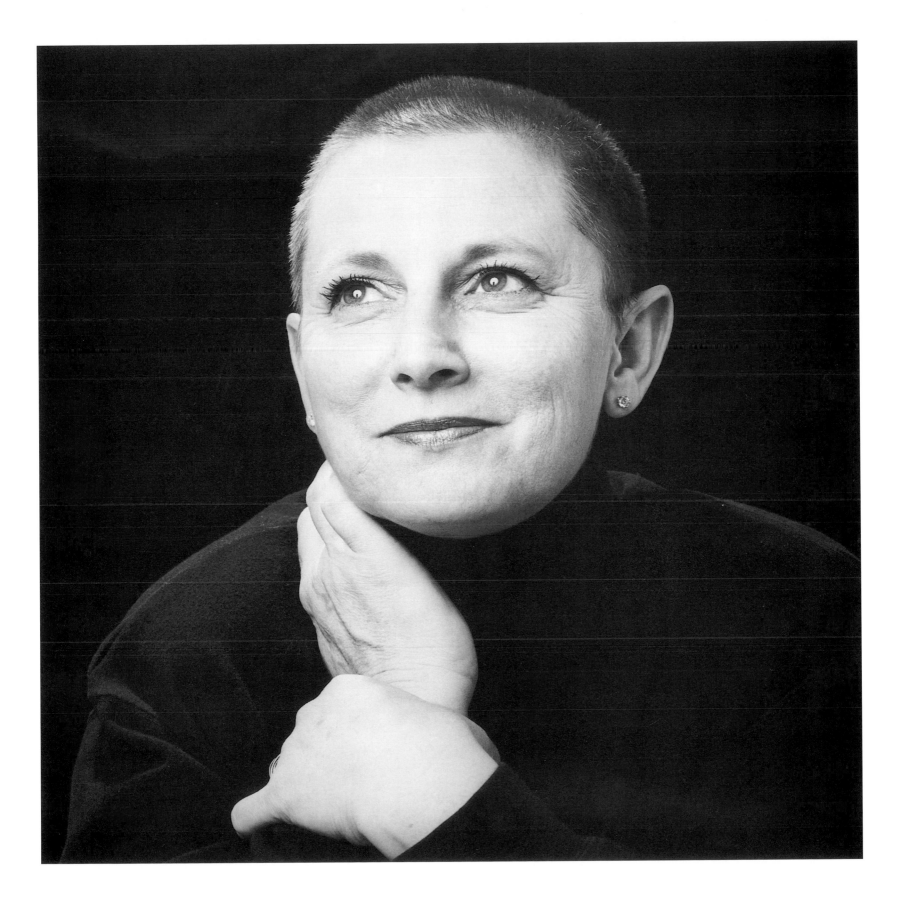

A N D R E A W I L K I N S O N

Born: 4/7/48

I didn't find my true love—in the most serious, reverent sense of the word—until I was forty-eight years old. I think

I've gotten it right this time! I met my soul mate, fell in love, got married, and have been living in an altered dream state ever since!

I thought such a relationship was theoretically possible, but I had never experienced it. It's as though I have finally found the other half

of me—as hokey as that sounds—after having pretty much given up. It's all the more incredible because of it being so unexpected.

With less than one year until my fiftieth birthday, I feel as though I've just embarked on the greatest adventure of all.

I feel a hope for the future and a level of enthusiasm for life which I have never felt before.

In a way it feels as though my life is just starting—not just a new chapter in the book that is my life,

but a whole new book in a new library! It's as though someone (I?) finally pushed the "unpause button" on my life.

It now seems as though anything and everything is possible.

I think there's chronological aging and then there's emotional/spiritual/mental aging—and there's not necessarily

any correlation between the two. My body is getting older, but inside I don't feel any different than when I was twenty-one—only calmer

and less anxious. I now have an inner peace and sense of being grounded—as though there were a gyroscope inside of me,

keeping me balanced. I feel I can move on to do whatever it is I came to this planet to accomplish.

All the experiences of my life so far have taught me that love is the most transformational force there is.

It may even be the energy that fuels the entire universe.

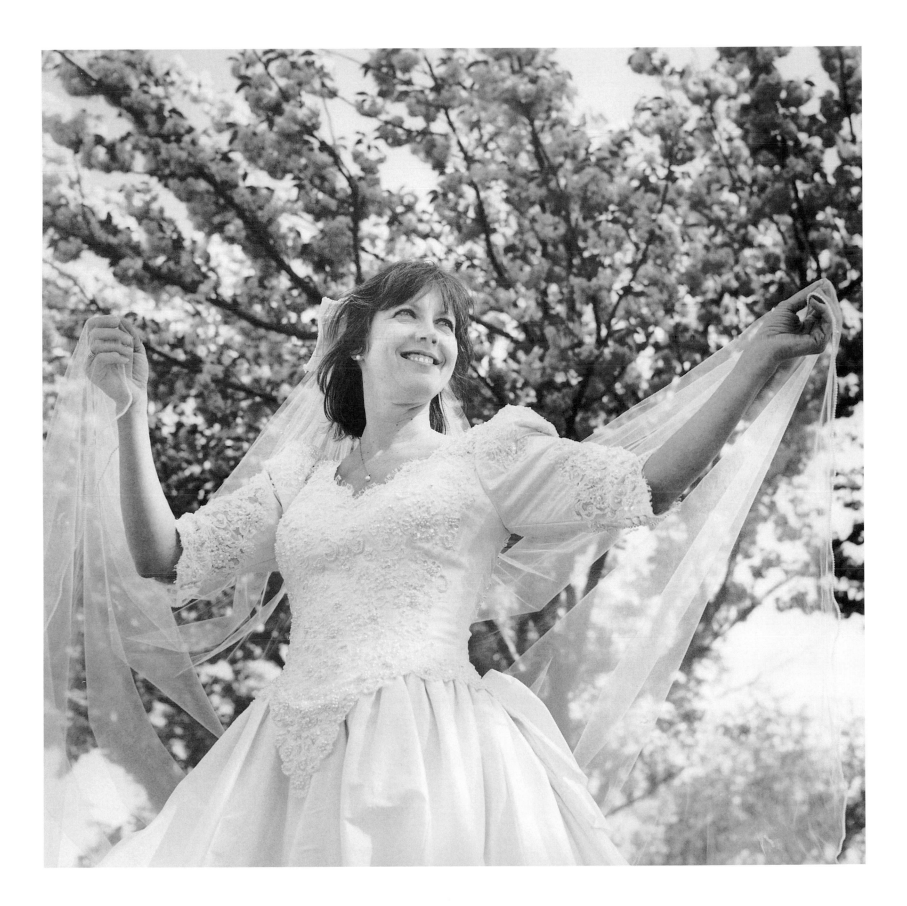

J U N E G R I S E T

Born: 6/6/42

My only concern about my appearance is how to keep the hair out of my eyes.

The way other people see me is not nearly as important as me being able to see things clearly.

I was raised to pour tea at ladies' luncheons. As the wife of a political figure, I have pretty much lived my life

trying to look like a good wife and mother. Now my husband is well ensconced in his career and my kids are grown,

so I don't have to worry about the motherhood/housekeeper/campaigner routine anymore.

I honestly didn't expect to reach this stage in my life.

When my kids were babies, I was already apprehensive about the empty-nest syndrome. Now I'm asking, "Can I help you pack?"

I've got another whole life ahead of me—not necessarily in years, but in terms of identity.

I really enjoy being alone and love having time to develop my art. I'm fascinated by figure drawing,

which I used in my career as a fashion illustrator. But I've always found commercial drawing too constrained, conforming, and limited.

I love the human body and movement, and want to show the human figure in new, expressive ways.

Now that I'm aging, I feel like a pioneer. No single generation before ours has had the potential to live as long as we may. The possibilities

for women surviving into their nineties is just beginning, and we'll stake new ground. If I live that long, I have to be ready for being alive.

I am a closet non-conformist.

There's a part of me that's a freedom-loving spirit, spontaneous, and outrageous—

a woman who loves nothing better than to let go of everything and fall back into a pile of leaves.

All my life I've collected and developed ideas. Now it's time to spill them!

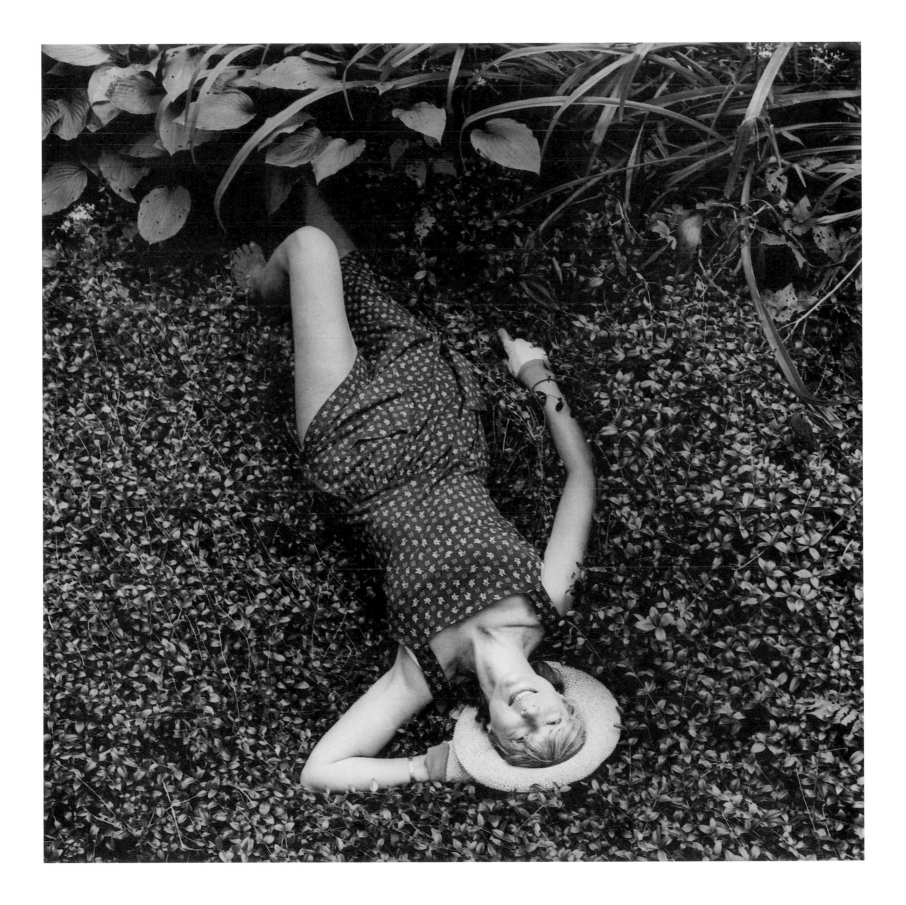

ACKNOWLEDGMENTS

We wish to thank all the women who participated in this work. It is from their integrity, honesty, and openness that this book derives its strength and beauty.

Devoted thanks to Arielle Eckstut of James Levine Communications, a remarkably adept, level-headed agent and a powerhouse of a woman. There is no one else we would rather have on our side.

Karmic gratitude to Will Glennon, Mary Jane Ryan, Claudia Schaab, Brenda Knight, and all the other fine folks at Conari Press who shared our vision and unhesitatingly committed to making it happen. We couldn't have been in better, more capable hands.

Our sincere appreciation to Olivia Goldsmith for believing in our work, and to her right-hand woman, Nan Robinson.

Special thanks to a wonderful handful of people: Susan Wooldridge; the Johanson family; Anne York; Dona Friedman; Susie Carman; Tom McGovern; Kathy Carroll and Eric Wilson; Adrienne and Jeff Gulino; Ken and Karen Anthony; and Edward and Barbara Zurmuhlen.

We also wish to thank all of the great candidates who we were unable to include in this book—you are all on "The Right Side of Forty!"

–P.M. And L.Z.

I offer great admiration and appreciation for my partner and friend Leif. His artistic integrity, brilliance, and forthright male energy helped make this work a true labor of love.

A thousand hugs to my husband, Richard, and Leif's wife, Jill, who provided absolute love and support and never once complained about being "widowed" by the book.

Love and perpetual thanks to Peggy Schaffer, the "Jimmy Stewart" in my "Wonderful Life."

–P.M.

Thanks and praise to Patricia Martin for her great concept and energizing collaboration. Big thanks to Richard Skiermont for his beautiful design and support. Love and thanks to Jill Anthony for her brutal but treasured honesty.

I would not have been able to complete this project without Mark Kozlowski's generosity, friendship, and support.

Thanks are also due to Vanessa Kostic of Kodak Professional and The Eastman Kodak Company for their generous support.

–L.Z.

TECHNICAL NOTES

All of the photographs in this book were taken with a Hasselblad 500C camera. Polaroid Polapan Pro 100 film was used for tests. The photographs were made with Kodak Tri-X film and printed on Kodak Polymax paper.

BIOGRAPHICAL INDEX

GRACE MARIE ANDERSON is a wife and mother who works with her husband at his chiropractic practice. She loves cooking and yoga, and laughter. Photographed at age 45. *Page 40.*

MARSHA R. BASLOE is Director of The Young Scholars Liberty Partnership Program, a job she finds challenging and rewarding. Photographed at age 44. *Page 26.*

RENATE BONGIORNO, photographed with her husband, Tom McGovern, is joyfully married and retired. She appreciates life and regards every day as a gift. Photographed at age 58. *Page 58.*

CATHERINE BRUMLEY is a health/fitness professional who lives with her "angel-in-a-dogsuit" named "Rosie." Photographed at age 45. *Page 44.*

SUSIE CARMAN is a jewelry designer who loves surfing and windsurfing, and has reached a state of contentment with life on two continents. Photographed at age 41. *Page 6.*

LINDA CHASE is a model and communications executive. Although she is known for her "Ethel Merman" grin, she confesses she is really very shy. Photographed at age 47. *Page 54.*

DR. PHYLLIS MALKIN COHEN is a doctor of the mind, teacher, mother, instrument of change, and seeker of truth. Photographed at age 55. *Page 94.*

CYNTHIA COULTER is a visual artist who shares a farmhouse with her boyfriend, one dog, and four cats. She can twirl a baton and, as an expression of conceptual performance art, once dumped a truck load of sand in front of her idol, Vito Acconci's, door. Photographed at age 46. *Page 22.*

CLAUDIA CUMMINGS is a wife, mother, and R.N./care manager in the insurance industry. She is a very good juggler with many balls in the air; when she occasionally drops one or two, she just keeps going. Photographed at age 40. *Page 92.*

DEBRA FERNANDEZ is a dancer and choreographer who has performed internationally. She loves the sensual in life, and says she is really a 1,000-year-old soul. Photographed at age 43. *Page 24.*

CHERI FRANCE and her husband, Leon, share life with their three lovely daughters, Nicole, Shanelle, and Noel, pictured with their mother. She helps support literacy through music, dance, and drama at an international school. Photographed at age 42. *Page 14.*

A quintessential hobbyist, SYLVIA FREEDMAN is a retired widow with three children who still keeps a hand in the family-run business. She loves being a woman so much she wishes she were two. Photographed at age 54. *Page 48.*

DONA MARA FRIEDMAN is an herbalist and co-owner of a retail shop that specializes in herbs, books, and gifts. Photographed at age 49. *Page 64.*

LINDA V. GADUS lives with husband, their fifteen-year-old "miracle son," and a golden retriever. Photographed at age 44. *Page 30.*

OLIVIA GOLDSMITH is a prolific author whose books include *The First Wives Club, The Bestseller, Flavor of the Month,* and *Marrying Mom.* She says her age is irrelevant. *Page 34.*

PEGGY GORMLEY, photographed with her dog, "Stevie Ray," is grateful for the company and love of her life partner Brian and Stevie Ray, and for the countless opportunities she has been given to become a more compassionate human being. Photographed at age 47. *Page 66.*

ELIZABETH GRAHAM'S grandmother, who lived to the age of ninety-seven, is her inspiration on how to age with humor, wit, and style. Photographed at age 41. *Page 82.*

LINDA GREENWALD is a divorced single mother of three children who loves running and would like to be remembered as someone who made the best out of the challenges that crossed her path. Photographed at age 44. *Page 88.*

An illustrator, JUNE GRISET is married with four grown daughters and a son. The older she grows, the more she wants to learn—she says she will always be a student. Photographed at age 54. *Page 110.*

ELIZABETH HENDERSON is a full-time organic farmer and spokesperson for the organic and sustainable farm movement. She organized and helped write *The Real Dirt: Farmers Talk About Organic and Low-Input Practices of the Northeast* and co-authored *A FoodBook: For a Sustainable Harvest.* Photographed at age 54. *Page 4.*

CATHERINE JOHANSON, with her dog, Puppio, is a hair stylist, make-up artist, and musician who lives with her husband, Rob, daughters Cathy and Melissa, their dog, Puppio, two birds, and a fuzzy rabbit. Photographed at age 40. *Page 74.*

TERRI JOHNSON is a designer and artist who lives independently and celebrates life with her two cats. Photographed at age 45. *Page 8.*

LINDA MARSHALL LAKE is a social studies teacher and exercise instructor who lives with her husband and two teen-aged sons. Photographed at age 45. *Page 98.*

PRISCILLA LAWRENCE is a daughter, sister, wife, mother, friend, teacher, student, and runner. Photographed at age 48. *Page 70.*

NINA LESOWITZ is a single mother of two young children who has recently made a transition into book publishing. She loves her friends, her boyfriend, travelling, reading, partying, and growing. Photographed at age 40. *Page 46.*

Founder of the Single Volunteers Network, ANNE LUSK is a super-energetic writer, researcher, and lecturer who has set out to change the world and make it a better place. Photographed at age 49. *Page 20.*

ANNETTE MADDEN is a customer service specialist at a book publishing company who lives with her mother, brother, youngest son, and the family dog. Photographed at age 52. *Page 102.*

LUZ HILDA MOLINA MALARET loves singing, music, dancing, and hats. She works raising funds for educational and health related projects that are oriented to women and children. Photographed at age 41. *Page 2.*

LORAINE M. F. MASTERTON is an actor "looking for ways to show stories while hoping to do justice to the georgeous terror of being human." Photographed at age 41. *Page 52.*

Author of *Buffalo Woman Comes Singing*, BROOKE MEDICINE EAGLE is an American native Earthkeeper, teacher, healer, song writer, ceremonial leader, and sacred ecologist. She is the creator of Eagle-Song, a series of spiritually-oriented wilderness camps, and founder of the FlowerSong Project, which promotes a sustainable, ecologically sound beauty path upon Mother Earth. Photographed at age 54. *Page 84.*

An outfitter to the cosmic cowpoke, RUBY MONTANA has a retail and mail order business based in Seattle, Washington, called "Ruby Montana's Pinto Pony." Her company specializes in mid-century furnishings, classic kitsch, and other fun stuff. She also sponsors the annual Spam Carving Contest, which raises funds for the local food bank. Photographed at age 49. *Page 96.*

MIRYAM MOUTILLET is a dancer, choreographer, and teacher who is still passionate for her art. She lives happily with her husband, Louis, and their young son, Tristan. Photographed at age 41. *Page 60.*

CHRISTIANE NORTHRUP, M.D. is an obstetrician/gynecologist and co-founder of Women to Women, an innovative health center located in Maine. She is the author of the acclaimed book, *Women's Bodies, Women's Wisdom*, and edits a national women's health newsletter. Photographed at age 47. *Page 16.*

VICTORIA OLTARSH is a single mother of two daughters, an actor, lyricist, theatrical director, choreographer, performer, and freelance teacher who has been meditating for twenty years. Photographed at age 44. *Page 80.*

BARBARA ANN PEDUZZI enjoys two vastly different careers: a cross-country truck driver and assistant producer of a summer stock theater company. Photographed at age 54. *Page 38.*

SUSAN PEERLESS has two children and is the executive director of a trade association. She feels the only never-ending aspect of life is "now." Photographed at age 49. *Page 86.*

An office manager, part-time model, and mother, DONNA MARIE PITANIELLO shares her life journey with her partner, Bob. Photographed at age 52. *Page 76.*

LINDA PODRAZIK is a karate teacher who lives with her husband, daughter, and two dogs. She owns and operates the martial arts studio, Fudoshin, which means "calm determination"–words she strives to live by. Photographed at age 43. *Page 78.*

DIANE PREZIOSO says, "I fell to the earth and burned like a shooting star; but I will rise like a phoenix and soar far above everything and everyone." Photographed at age 50. *Page 106.*

THELMA PRICE, photographed with her son, Laki's, turtledove, is a substance abuse counselor and HIV/AIDS activist who lives with her two sons and darling granddaughter. Photographed at age 42. *Page 28.*

A former public health nurse, GRACE C. J. ROSS is a pastor and chaplain in the United Methodist Church. She has been married thirty-eight years and has three grown daughters and one granddaughter. Photographed at age 61. *Page 62.*

JUDITH ROTH is an antiques dealer, community volunteer, and mother who enjoys the differences in people and travel. She lives with her husband and two cats. Photographed at age 58. *Page 56.*

American artist and founder of the QE2 night club, CHARLENE SHORTSLEEVE lives in a pink brownstone. Photographed at age 46. *Page 42.*

LYNNE SIGNORE is a commercial stylist who finds great joy being surrounded by her two beautiful children and her husband, Richard. Photographed at age 42. *Page 18.*

AURORA SMITH is a retired innkeeper who shares life with her husband, Gregory, and three "gentle giant" dogs. Photographed at age 63. *Page 100.*

GAIL STRAUB has been a teacher and activist in the arena of consciousness development for more than twenty years. Together with her husband, David Gershon, she founded Empowerment Training Programs, a training and consulting company, and co-authored the book Empowerment: *The Art of Creating Your Life as You Want It*. Photographed at age 48. *Page 36.*

LEANNE SWEET, photographed with dance partner Alan Yates, is the mother of four and grandmother of two who divides her time between running a bone marrow donor recruitment organization and teaching ballet. Photographed at age 54. *Page 50.*

SHARON WEISBERG supports herself working full-time, and continues to explore herself, her relationship with her two children, and the meaning of mortality. Photographed at age 50. *Page 12.*

A partner in a construction firm, NOREEN WEST (shown with Taylor, her youngest daughter) is a wife and mother of two daughters. Photographed at age 40. *Page 104.*

ANDREA WILKINSON is a newly remarried mother of four children who works at a university art history slide library as a curator/archivist. She also runs her own proofreading/editing/writing business. Photographed at age 49. *Page 108.*

A busy wife, mother, and grandmother, MARY BEATRICE WILLIAMS is also an artist, lecturer, and community volunteer. Photographed at age 50. *Page 72.*

SANDY WIMER is a wife, mother, artist, and adjunct assistant professor of printmaking. Photographed at age 44. *Page 32.*

SUSAN GOLDSMITH WOOLDRIDGE is a poet, teacher, and the author of *poemcrazy: freeing your life with words*. Excerpts from her lifelong journal appear in *The Writer's Way*. She is currently putting together another book. Photographed at age 51. *Page 68.*

PATRICE WYNNE is a visionary business woman who lives with life partner, Eric, and is the co-owner of the Gaia Bookstore and Community Center in Berkeley, CA. Photographed at age 45. *Page 90.*

Also known as "Foxy," ANNE YORK is a wife, mother, and public relations diva with a green thumb. Photographed at age 50. *Page 10.*